R.D. Cole Manufacturing Company

IMAGES *of America*

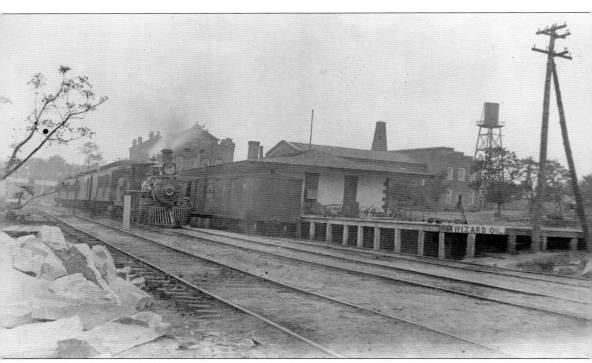

This photograph shows a train stopped at the Historic Train Depot in Newnan, Georgia. The R.D. Cole Manufacturing Company frequently used the depot as a hub to ship their products. The manufacturing plant can be seen in the background (across the street) along with a water tank located on the company's campus. (Courtesy of the Newnan-Coweta Historical Society.)

ON THE COVER: This 1929 photograph shows the R.D. Cole Manufacturing Company workforce in front of the company office building. Employees are photographed sitting on a riveted cylinder manufactured by the company. Started in 1854, the R.D. Cole Manufacturing Company became one of Coweta County's oldest businesses before its closing after 100 years in business. Much of the company's success can be attributed to the hardworking and dedicated employees who worked at the company along with the ability and talent of the Cole family to bring together great men and women to build successful businesses. (Courtesy of Duke and Lynn Blackburn.)

IMAGES *of America*
R.D. COLE MANUFACTURING COMPANY

Dr. Emily Kimbell on behalf of the
Newnan-Coweta Historical Society
Foreword by Duke Cole Blackburn Jr.

Copyright © 2022 by Dr. Emily Kimbell on behalf of the Newnan-Coweta Historical Society
ISBN 978-1-4671-0779-2

Published by Arcadia Publishing
Charleston, South Carolina

Printed in the United States of America

Library of Congress Control Number: 2021949402

For all general information, please contact Arcadia Publishing:
Telephone 843-853-2070
Fax 843-853-0044
E-mail sales@arcadiapublishing.com
For customer service and orders:
Toll-Free 1-888-313-2665

Visit us on the Internet at www.arcadiapublishing.com

*Dedicated to the former employees of R.D. Cole
Manufacturing Company and their families*

CONTENTS

Foreword		6
Acknowledgments		7
Introduction		8
1.	The First 50 Years	11
2.	The Founding Family	29
3.	A Period of Growth	49
4.	Impact on the Local Community	71
5.	Working at R.D. Cole	95
6.	The End of an Era	113
About the Newnan-Coweta Historical Society		127

FOREWORD

First and most importantly, I need to thank my wife, Lynn, for her hard work and dedication in compiling all the information contained in this book. Without her diligence to completeness and detailed accuracy, this account of the Cole family and their many successful endeavors would have been impossible to document. Cole family members and the community now have a complete pictorial history of one of Newnan and Coweta County's premier leading industries.

As you will read, the Cole family, as well as many others, had to endure extreme hardships while helping to settle the new America. We truly believe that R.D. Cole Sr. and his family overcame overwhelming personal hardships through their strong Christian beliefs and faith in God. Sincere gratitude is owed not only to our Cole ancestors but also to the many loyal and dedicated longtime employees and their families of the R.D. Cole Manufacturing Company that helped shape Newnan into one of Georgia's and the Southeast's most successful and influential cities.

No one could ever imagine that a broken-down wagon and individuals with extremely strong faith and an incredible work ethic would drive a small wagon repair shop to become one of the nation's leading industries. This truly wonderful part of local history certainly could be a model for success in business when faith and hard work are sustained.

I cannot say enough about the many skilled and dedicated employees who were considered by the family to be the highest asset to the company. A quote written in the souvenir book from the company's 50th anniversary celebration in 1904 supports this belief: "The founders of the business have at all times been sustained in the fullest measure by all their co-laborers and employees in their efforts to set a high standard for their enterprise."

For a company to endure for over 100 years as did R.D. Cole Manufacturing Company, it must be able to diversify and most importantly keep up with ever-changing techniques and technological innovations to be more labor efficient. Skilled craftsmen and highly trained technical personnel will always be in great demand. It will also take a risk-taker to put forth the dedication and capital to make a business truly successful. The formation of R.D. Cole Manufacturing Company in its early years is a true testament to what can happen when first ownership takes a huge risk of capital and then the labor force contributes to producing a final product. As with R.D. Cole Manufacturing Company, ownership, management, and employees worked together as one large family to build a business that stood the test of time.

Thank you to all the Cole family members and former employees for their individual contributions to this book, especially to my special cousin Ed Cole III, who, like myself, had the privilege of growing up and working at Cole Shop. Ed's input and enthusiasm about R.D. Cole Manufacturing Company is greatly appreciated. The pictorial documentation could not be possible without the support of the Newnan-Coweta Historical Society and Emily Kimbell, who has steadily directed the Cole family descendants as far as content, details, and time line.

All proceeds from the author's book sales are being donated to the Newnan-Coweta Historical Society by the Cole family. Thanks to all you who have purchased a copy. Hopefully, this book can be passed down to future generations so that they can better understand the main factors that have made Newnan and Coweta County such a wonderful and unique community.

—Duke Cole Blackburn Jr.

ACKNOWLEDGMENTS

This book would not be possible without Duke and Lynn Blackburn opening up their home and allowing me on behalf of the Newnan-Coweta Historical Society to look through their family archives. I am so grateful that they entrusted me with not only the care of their priceless family documents and photographs but also with sharing the history of their family. For that trust and their friendship, I am so grateful. Duke and Lynn worked tirelessly to track down dates, information, and pictures. They are the reason this book exists, and I hope the story of their family inspires others and serves as a wonderful tribute.

On behalf of myself and the Blackburn family, we would like to especially thank descendants of the Cole family who provided pictures, information, feedback, and recollections that contributed to the depth of this book. Specifically, we would like to thank Ben Blackburn, Will Blackburn, Ed Cole, Matt Cole, Ruth Hammett, Otis Jones III, Louise Parham, Mathew Pinson, and Minerva Winslow

We also thank Doug Boswell, Veronica Dorsey, Dwight McCrary, and McKoon Funeral Home for their contributions.

We thank the City of Newnan for allowing the Newnan-Coweta Historical Society to visit and photograph the previous site of the R.D. Cole Manufacturing Company.

We thank the board and staff of the Newnan-Coweta Historical Society for their support in completing this book and the use of their archival material.

Finally, Duke, Lynn, and I thank our individual families for their love and support. The story of R.D. Cole Manufacturing Company is a story of family, and we certainly could not have completed this project without ours. We know the love and care present during the time of R.D. Cole Manufacturing Company is still present in our own families today.

Unless otherwise noted, all images appear courtesy of Duke and Lynn Blackburn.

INTRODUCTION

"A broken wagon, strong faith, and hard work"—these aspects are what the Cole family believes caused R.D. Cole Sr. and R.D. Cole Manufacturing Company to become successful for so long. When the Cole family moved to Coweta County in 1849, the family had no intention of living in the area permanently. However, a broken wagon that forced the family to set up a shop in the area became inspiration for the creation of a small, private woodshop. In 1854, R.D. Cole Sr. established the firm of Cole & Barnes as a sawmill. The company saw near immediate growth and began manufacturing sawmills, cornmills, boilers, and engines; contracting and constructing buildings and housing units; and eventually, manufacturing steel, aluminum, and alloy. By the 1890s, R.D. Cole Manufacturing Company was the second-largest water tower manufacturer in the United States; at the time of the sale of R.D. Cole Manufacturing in 1968, it was the oldest company in Coweta County.

When the R.D. Cole Manufacturing Company was initially founded in 1854, Coweta County was experiencing a period of growth. Newnan had just been made the county seat a few decades prior in 1828, the first courthouse had been built in 1829, and land lottery winners were moving into the state bringing their businesses with them. By the late 1840s and early 1850s, Coweta County was already moving into an age of prosperity. The railroad had built lines in the county. Schools of all levels, both preparatory and higher level, were available and prosperous for men and women. The agricultural and cotton industries were also becoming major aspects of the local economy.

Once established, the R.D. Cole Manufacturing Company contributed to Coweta County's growth and solidified the county as a manufacturing center. Due in part to R.D. Cole Manufacturing Company's success and the other business ventures of the Cole family, Newnan became one of the wealthiest cities in the country during the mid-1800s.

However, the history of R.D. Cole Manufacturing Company is more than a story about a business and its products. It is the story of a family who was unafraid to start over despite encountering prior loss and who was willing to pour their life into the betterment of their community. The Cole family clearly loved Coweta County and was proud of where they lived. They treated their employees with relative fairness and kindness. Even today, over 165 years since the start of R.D. Cole Manufacturing Company and 50 years since its closing, people still recall fond memories of working for the manufacturer. Much of the company's wealth and business resources were donated to local charities and churches, and their craftsmanship and handiwork are still seen across the county from public government offices to private residences.

R.D. Cole Manufacturing Company has always been a family affair. From the very beginning, R.D. Cole Sr. and his brother Mathew led the business, and the two brothers saw the company through its first 50-plus years. Mathew's five sons continued the legacy and became instrumental in the development of the company, and for six more generations, members of the Cole family worked at the family business. Every member of the family was a valuable contribution to the company's success—sons learned the family business and took leadership positions, wives served on the board and owned stock, and children worked in small capacities from even a young age.

Even when the company was sold outside of the family, the memory and meaning of R.D. Cole Manufacturing Company remained. The Cole family has quite literally held onto the memories of the family business in the records, photographs, newspaper clippings, and documents kept

through generations for hundreds of years. By showcasing these family documents, these pages give just a small glimpse into the life of a family, a company, and a community. Though the entire story and impact of R.D. Cole Manufacturing Company cannot be encapsulated in these short number of pages, this pictorial history of the company demonstrates the love and care that went into building one of the greatest manufacturing businesses in the Southeast and shows how one person and one family can make a permanent difference in their community.

One
THE FIRST 50 YEARS

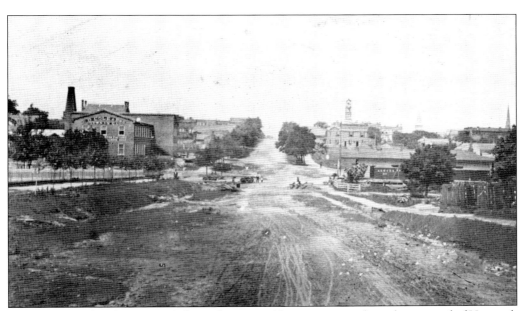

This photograph, taken in 1885, shows downtown Newnan as seen from the east end of Hancock Street, now known as East Broad Street. The R.D. Cole building can be seen on the left. Founded in 1854, R.D. Cole Manufacturing Company grew from modest beginnings to become one of the leading manufacturers not only in Coweta County but also throughout the Southern United States. (Courtesy of the Newnan-Coweta Historical Society.)

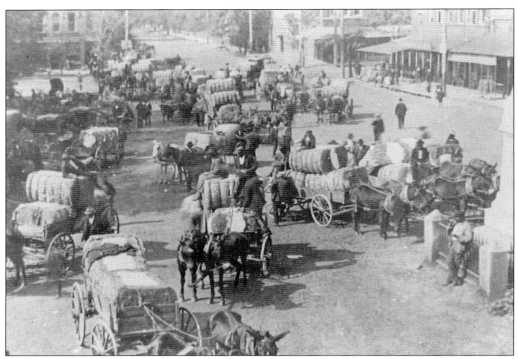

Coweta County was founded in 1825 after the Treaty of Indian Springs and subsequent forceful removal of Native Americans from the land. In 1828, the county seat of Newnan was established by pioneers of the area. The Cole family moved to the area in the mid-19th century, when Coweta County was starting to see exponential growth, to which the family certainly contributed. Above is a busy market day at North Court Square in downtown Newnan during the late 19th century. Below is a picture of downtown Newnan in the 1890s labeled "court square in days of cobblestones." The courting couple is unidentified. (Both, courtesy of the Newnan-Coweta Historical Society.)

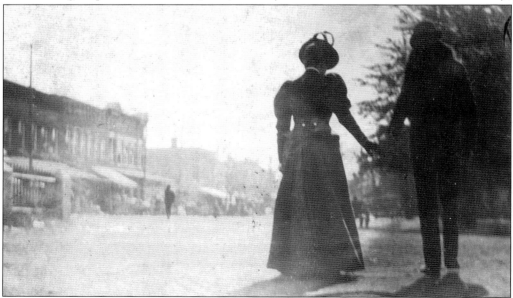

This sketch portrays R.D. Cole Sr., founder of the R.D. Cole Manufacturing Company, along with his signature. Upon his death in 1910, citizens and business associates all over Georgia and the Southeast mourned the passing of such an influential man. Cole's obituary, published on June 3, 1910, in the *Newnan Herald and Advertiser*, describes Cole as "a builder, with a genius for conception, an ability for achievement, and a wise judgement and forethought that are possessed by few."

In 1849, R.D. Cole Sr. and his wife, Martha, left Campbell County (what is now Fulton County) and headed for Alabama. On the way, their wagon broke down near downtown Newnan. While Cole was repairing his own wagon, others brought their wagons for repair prompting the family to settle in town. This picture shows an unidentified man in Newnan driving a wagon similar to those the Cole family repaired for locals. (Courtesy of the Newnan-Coweta Historical Society.)

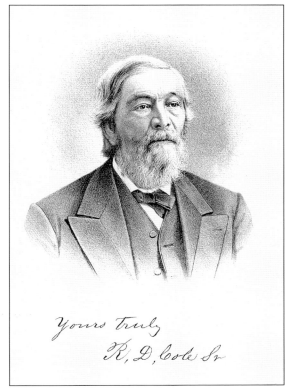

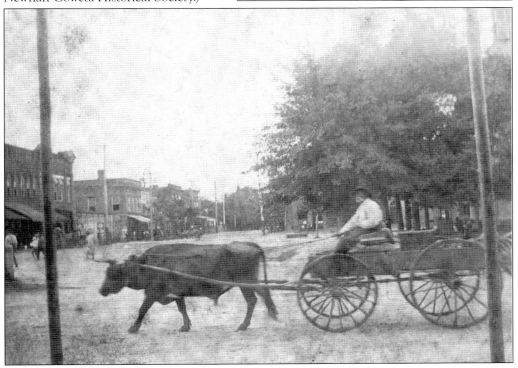

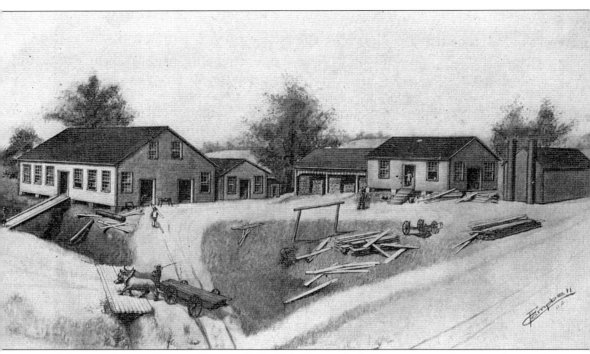

After moving to Coweta County, R.D. Cole Sr. worked as a carpenter for several years in a small 24-by-36-foot wood-frame shop. Cole had no machinery and did all of his carpentry and blacksmithing work with hand tools, specializing in the manufacturing of sash and doors. In 1854, he partnered with his brother-in-law Thomas Barnes to form the Cole & Barnes Company. In 1855, R.D. Cole's brother Mathew purchased Barnes's interest, and the company became known as R.D. Cole & Brother. Soon after, W.T. Cole, a nephew, was admitted to the partnership changing the company name to R.D. Cole & Company. In 1872, after Mathew's sons began joining the firm, the company was renamed the R.D. Cole Manufacturing Company—its final and most well-known title.

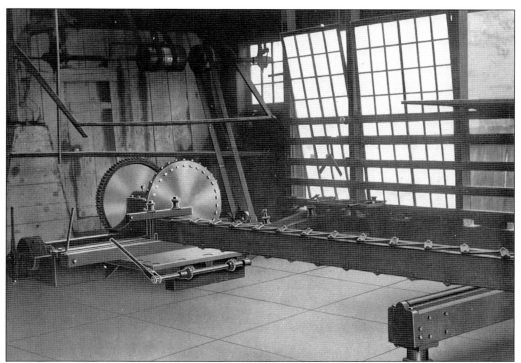

During its first year of operations, the Cole & Barnes company employed six workers and conducted $5,000 worth of business. The company was established as a planing mill run by a five-horse engine—the first ever to be brought to Coweta County. Pictured here is a rotary planer that was located at the R.D. Cole Manufacturing Company plant.

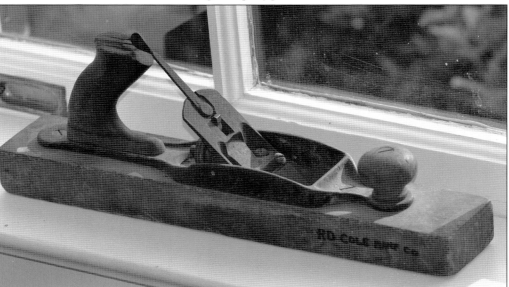

Pictured here is an original R.D. Cole wood planer tool that would have been used during the company's early years of operations. The tool has been handed down through the Cole family for generations.

15

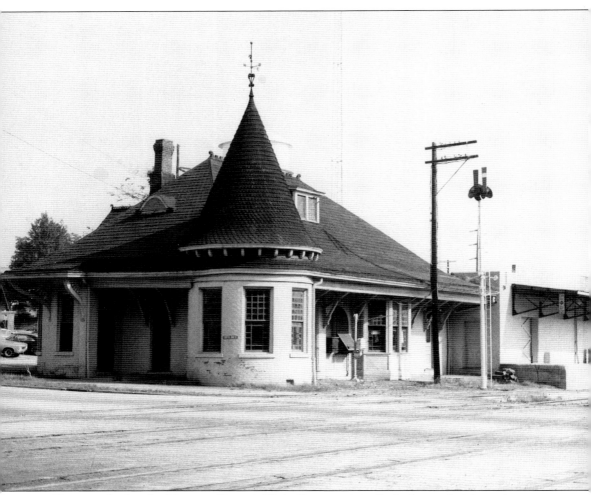

Photographed is the Newnan Historic Train Depot, originally built as a freight and passenger depot for the Atlanta & West Point Railroad in the 1850s. In 1857, while in the depot, R.D. Cole Sr. came across a bill (in a trash pile) from Augusta, Georgia, showing the price of sash at 15¢ per light and doors at $3.50. He realized that he needed machinery in order to compete with current prices and commissioned the purchasing of a foot mortising machine. (Courtesy of the Newnan-Coweta Historical Society.)

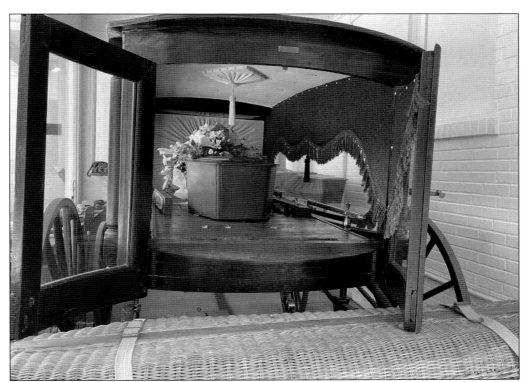

Photographed is a wooden coffin from the 1800s inside an old carriage hearse on display at McKoon Funeral Home & Crematory in Newnan, Georgia. The R.D. Cole Manufacturing Company made coffins during the early 1850s. It was customary at the time for coffins to be "tailor-made" after an individual passed away. This custom often necessitated calling men into work on Saturday night or Sunday. R.D. Cole Sr. particularly objected to Sunday work and decided to premake a few coffins for storage. The decision was met with controversy from the community who accused Cole of wanting people to die so that his business could make a sale. However, Cole stuck to his belief and continued to carry wooden coffins in stock. The boycott was short-lived.

R.D. Cole Sr. bought the first cooking stove ever seen in the county from Ike Collier in 1855 for $37.50. As seen in this advertisement, the R.D. Cole Manufacturing Company later produced cast-iron heating stoves.

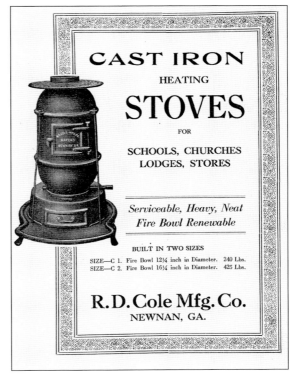

The R.D. Cole Manufacturing Company built its first gristmill in 1860 due to public need. At the time, resources were limited due to the impending war. The mill saw daily crowds of farmers bringing their corn to be ground to meal. The company continued to both expand its own mills and manufacture mill machinery for outside sales. It advertised the following: "Gears Are Made from Best Quality of Iron." Pictured here is Falls Mill, an example of an early gristmill. Falls Mill was an 1873 cotton and woolen factory in Belvidere, Tennessee. The factory was later converted to a cotton gin, then woodworking shop and gristmill. Today, the mill houses the Museum of Power and Industry, Inc., including a stone gristmill built by the R.D. Cole Manufacturing Company in 1900. (Both, courtesy of Falls Mill and Museum in Belvidere, Tennessee.)

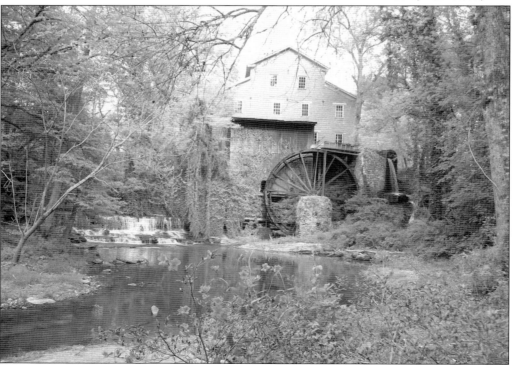

Around 1860, R.D. Cole Sr. took a risk with the company when he started a sawmill in the cellar of the planing mill. Cole designed the machinery himself with a saw swinging from the overhead supporting beams over the wood to be cut. The new machinery cost $40 to create. This drawing from 1908 crafted by the engineering department at the R.D. Cole Manufacturing Company depicts a swing cutoff saw. This machinery was used to help construct the doors and sashes manufactured by the company.

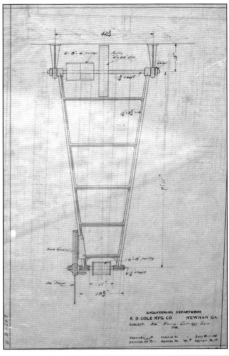

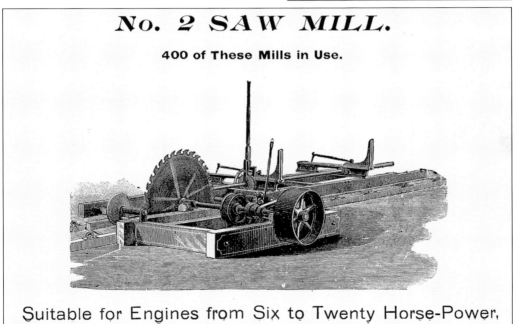

Cole received criticism and doubt regarding the sawmill's success; however, the decision proved to be profitable. After the Civil War, the R.D. Cole Manufacturing Company sawmill was the only one between Macon and Augusta, Georgia, that had not been destroyed by the Union army. By 1894, the company was manufacturing and selling sawmills for a starting price of $250 as listed in its catalogue of machinery.

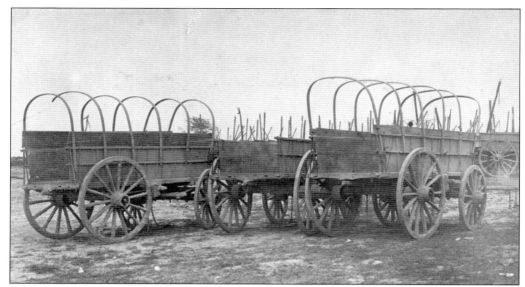

Most of R.D. Cole & Brother's production between 1861 and 1865 was dedicated to the Civil War. The company produced about 100 wagons for the Confederate government. One of these wagons had the capacity to hold 6,000 pounds. It was sold to the government for $60 and nicknamed, "the Great Western." This photograph by Andrew J. Russell taken on July 5, 1865, shows three wagons, like those created by R.D. Cole Manufacturing Company, probably used for army supplies during the Civil War. (Courtesy of the Library of Congress.)

Photographed is a reunion of Civil War veterans of the 7th Georgia Regiment on July 28, 1905. During the war, R.D. Cole & Brother contracted with the Confederate government to use its mill to furnish meals to the families of soldiers. Mathew Cole briefly served in the war as first sergeant of the Georgia Militia also known as "Joe Brown's Pets." He returned to Newnan by petition as a home guard to run the gristmill. (Courtesy of the Newnan-Coweta Historical Society.)

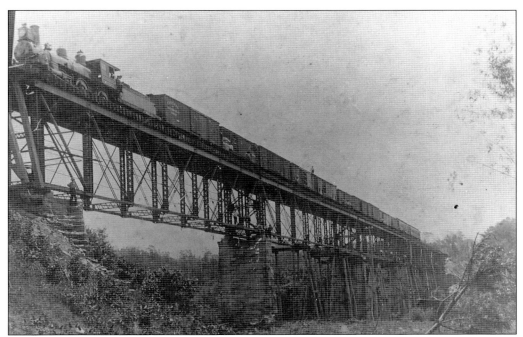

During the Civil War, R.D. Cole & Brother made train trestles 110 feet long to repair the Long Cane Creek bridge in Troup County. The bridge had washed away while the Confederate Army was moving from Vicksburg to Richmond. The promptness and energy of the company's work impressed officials of the Atlanta West Point Railroad. Shortly after the war, a railroad car broke down near Newnan, and R.D. Cole & Brother was hired to repair it. The railroad was so pleased that it contracted with the company to build and repair all cars used by the railroad. This business relationship lasted for 17 years. Above is a 1950s image of a train trestle running above the Chattahoochee River near Plant Yates in Coweta County. Below is the Wahoo Creek Railroad Bridge in Coweta County. These trestle bridges are similar to the one repaired by R.D. Cole & Brother. (Above, courtesy of the Newnan-Coweta Historical Society; below, photograph by Benjamin Cole Blackburn.)

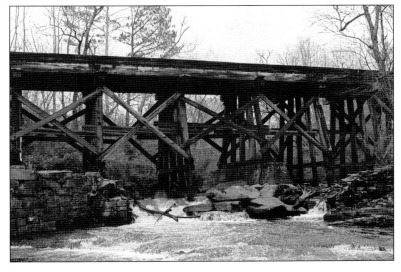

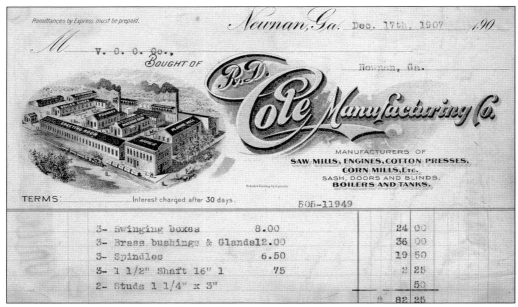

The R.D. Cole Manufacturing Company added a foundry in 1875 at a time when Mathew's five sons were finishing college and joining the company as executives in the management and engineering departments. By 1907, the company had expanded its operation and was manufacturing steam engines, boilers, and tanks. The receipt pictured here from December 1907 shows a sale from the foundry and the planing mill.

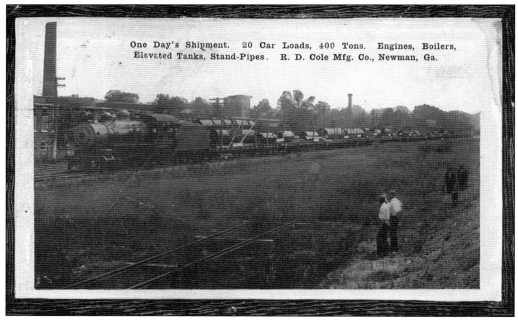

This photograph, taken at the turn of the century, showed one day's shipment of 20 carloads and 400 tons from the R.D. Cole Manufacturing Company. By 1905, the semicentennial of the R.D. Cole Manufacturing Company had freight bills of $80,000. However, the company had grown to annual outputs of $600,000 a year with employment of over 500 people.

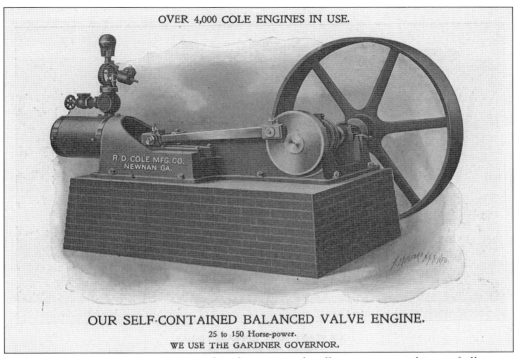

OVER 4,000 COLE ENGINES IN USE.

OUR SELF-CONTAINED BALANCED VALVE ENGINE.
25 to 150 Horse-power.
WE USE THE GARDNER GOVERNOR.

In the 1800s, steam engines were used in factories and mills to power machines of all types. Pictured above is the self-contained balanced valve engine designed and manufactured by R.D. Cole Manufacturing Company. By 1911, over 4,000 Cole engines were in use. Below is a picture of a water-front, water-bottom portable boiler, one of many designs of boilers manufactured by the Coles. The Cole shop was equipped with the latest high-class tools of the time, along with skilled mechanics, enabling them to produce a line of boilers it advertised as second to none.

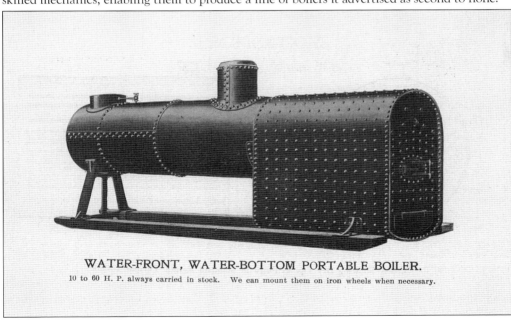

WATER-FRONT, WATER-BOTTOM PORTABLE BOILER.
10 to 60 H. P. always carried in stock. We can mount them on iron wheels when necessary.

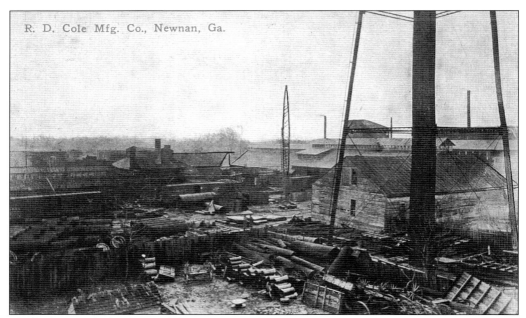

Shown here is the lumberyard that was located across the street from the main Cole plant. The company continued carpentry work and construction until the 1960s, when it sold the lumber operation to Hollis Lumber & Supply Company, a family-owned business in Newnan.

This 1907 postcard shows the 14-story Empire Building, located at the corner of Marietta and Broad Streets in downtown Atlanta. Built in 1900, the Empire Building served as the location for the R.D. Cole Manufacturing Company Atlanta Office. Edwin Marcus Cole was the manager of the Atlanta office and had a home in Newnan and an apartment in Atlanta, located at 316 in the Empire Building.

This picture from 1893 of Five Points in Atlanta, Georgia, shows an R.D. Cole–manufactured water tower. During the 1890s, R.D. Cole Manufacturing Company began designing water tanks and towers. The company became known as an innovator and pioneer of water tank designs. It was the first to design an elevated tank supported by tubular columns. This tank is an example of one of the earliest elevated steel tower tanks.

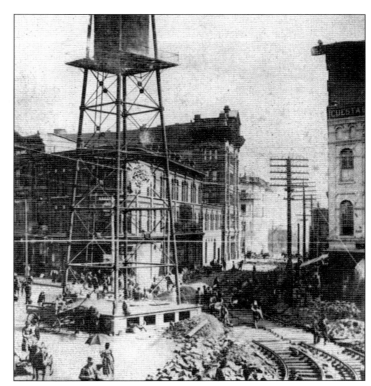

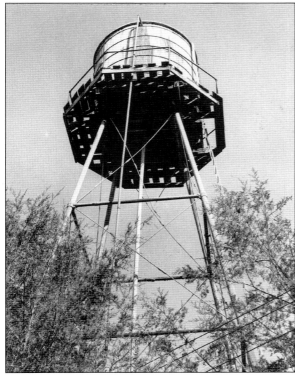

Pictured is an elevated water storage tank built of wood located in Seale, Alabama. Constructed and pictured in the 1890s, this was one of the first water tanks built by R.D. Cole Manufacturing Company.

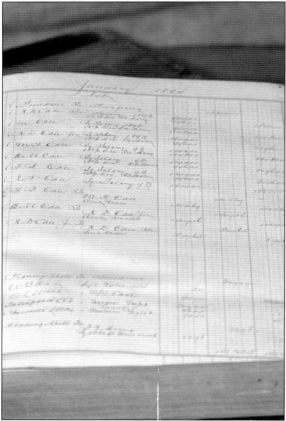

By 1904, R.D. Cole Manufacturing Company had grown to such proportions that it carried 535 people on its payroll and had annual outputs of $600,000. Photographed are ledger books from the late 1800s kept by descendants of the Cole/Blackburn family. The ledgers contain information about employee payroll. The inside of one ledger notes the date January 1894.

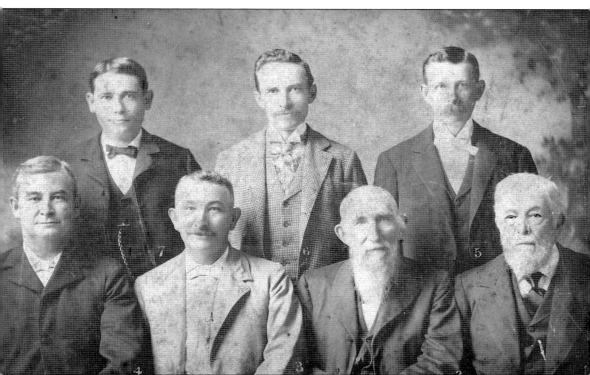

Pictured in the 1890s are the central members of the Cole family responsible for the early development, growth, and success of the R.D. Cole Manufacturing Company. Pictured are, from left to right, (first row) Madison Filmore Cole (general manager), R.D. Cole Jr. (superintendent), Mathew Cole (vice president), and R.D. Cole Sr. (president); (second row) Roy Nall Cole (treasurer), Frank Bartow Cole (engineer), and Edwin Marcus Cole (manager of the Atlanta office). The Cole family owned and operated the R.D. Cole Manufacturing Company through five generations. The company impacted the community both economically and aesthetically as many of the houses and businesses were built by its skilled carpenters using lumber from the planing mill.

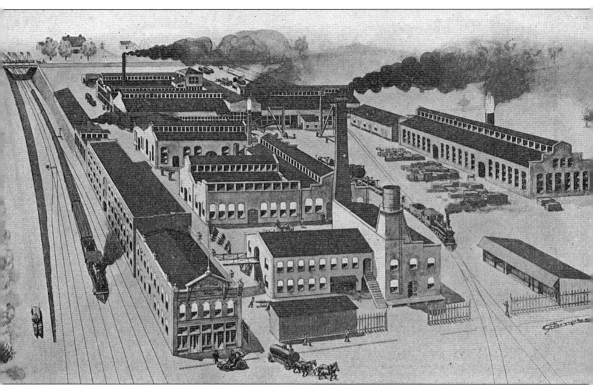

In 1904, fifty years after the start of the R.D. Cole Manufacturing Company, operations had expanded to include the manufacturing of engines, mill work, boilers, standpipes, steel trestles, tanks, steel stacks, bridges, and steel buildings among housing materials and other items. The photograph shows a stark difference in the size of the company as it grew greatly from its one-room building into the large industrial plant that made Newnan the center of a highly industrialized belt extending from Eastern South Carolina to South Central Alabama.

Two
THE FOUNDING FAMILY

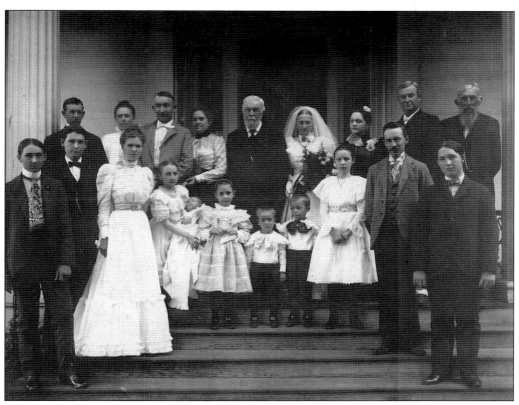

R.D. Cole Sr. and Martha Cole celebrated their 50th anniversary in 1898. Pictured here are, from left to right, (first row) Guy Cole, Roy and Jenni Cole, Ruth Cole (holding her baby sister Catherine), May Cole, Raymond Cole, Edwin Cole, Christine Cole, Frank Cole, and Stewart Cole; (second row) Ed and Mattie Cole, R.D. Cole Jr. and Fannie Cole, R.D. Cole Sr. and Martha Cole, Bertha and Madison Filmore Cole, and Mathew Cole. (Courtesy of Mathew Pinson.)

Pictured here is the Cole family crest. John Cole's family was the first to come to America, originally immigrating from Scotland by way of Ireland. Born near Edinburgh, Scotland, in 1728, John Cole first moved from Scotland to North Ireland on account of his family's Presbyterian religious beliefs. Around 1740, when John was around the age of 12, the Cole family immigrated to America and settled in North Carolina. John married Lucy Cole and, eventually, died in 1808 in Greene County, Georgia. John and Lucy's son William was a soldier in the Revolutionary War and served in the North Carolina militia. William died of starvation during the war after being captured as a spy by two British soldiers. His last letter to his family describes his experience of having nothing to eat but the corn dropped by the horse's mouth in the prison camp. After his death, William's widow, Hannah, along with John Cole, moved their family from Surry County, North Carolina, to Oglethorpe County, Georgia. (Courtesy of Minerva Cole Woodroof Winslow.)

Robert Cole (pictured at right), son of William and Hannah Cole, was born July 6, 1775, in Surry County, North Carolina. Robert worked as a farmer, landowner, and mill operator. He married Elizabeth Fambrough in 1796 while living in Oglethorpe County, Georgia. Elizabeth Fambrough Cole (pictured below) was born October 7, 1778, in Halifax County, Virginia. Census records indicate that Robert and Elizabeth moved first to Greene County, now named Newton County Georgia, and lived on what is now the Gaither Farm where they ran a gristmill and farmed. A costly legal battle spurred the family's move across Georgia to Jasper County, Henry County, and, finally, Campbell County (now Southern Fulton County) where they built a home. The couple had 12 children with 26 years between the oldest born in 1797 and youngest child in 1823. Robert died on March 20, 1852, and Elizabeth died on August 12, 1863. They are both buried in Oak Hill Cemetery in Newnan, Georgia.

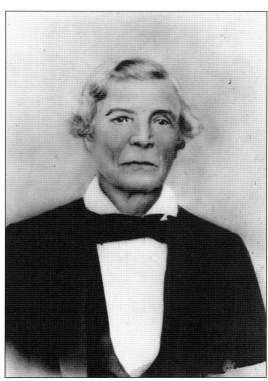

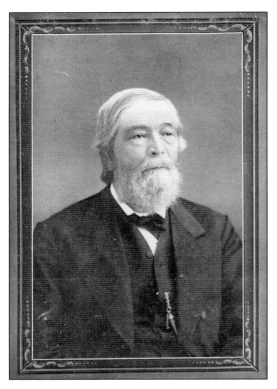

Robert Duke Cole, son of Robert and Elizabeth Cole, was born in Newton County, Georgia, on December 21, 1820. Known as R.D. Cole Sr., he grew up learning the trade of farm life and helped operate the family gristmill. At the age of 10, his family moved to Campbell County, and while in his teen years, he taught school. R.D. Cole Sr. was the founder of the R.D. Cole Manufacturing Company and one of the founders of the Newnan Cotton Mills. He served as president of both companies until his death on June 3, 1910.

Martha Burrell Overby was born on August 14, 1827, in Brunswick County, Virginia. She was affectionately nicknamed Ms. Pink. She married R.D. Cole Sr. on September 9, 1849, in Coweta County, and after 18 years of marriage, they had one son. Martha died on March 12, 1907, at the age of 79 years old and is buried in Oak Hill Cemetery in Newnan, Georgia, alongside her husband.

Thomas "Tommie" Robert Cole was the only child of R.D. Cole Sr. and Martha Cole, born on May 11, 1866. Nicknamed "the Boss Boilermaker," he was said to be a pledge of love after a fruitless union of 18 years. Thomas worked at the R.D. Cole Manufacturing Company, attended school, and played in the Kehr Brass Band in Newnan. Sadly, at the age of nineteen and two months, Tommie died of "rheumatism of the heart."

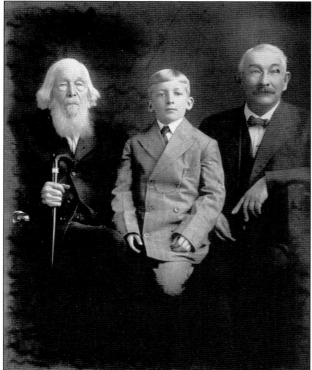

Three generations of the Robert Duke Cole namesake pose for a family photograph. R.D. Cole Sr. is seated left. His nephew R.D. Cole Jr. is seated right, and Mathew Cole's grandson, R.D. Cole III is seated center. R.D. Cole Sr. and Jr. both served as presidents of the company. R.D. Cole Sr. entrusted his nephews (Mathew Cole's sons) with the Cole legacy, making them predecessors to his company. He wrote, "They have been as much a son to me as if my own son had lived."

Mathew Cole (alternatively spelled Matthew Cole) was born on January 25, 1823, in Jasper County, Georgia, as the youngest son of Robert and Elizabeth Cole. He was raised on the family farm and received limited schooling, mostly acquiring trade skill training in wagon making. He was a founder and vice president of R.D. Cole & Brother, later R.D. Cole Manufacturing Company, where he served as vice president until his death. He also helped organize the Coweta Cotton Oil Company and the Coweta Fertilizer Company, serving on the board of directors for both. Mathew died on February 18, 1907, in Newnan, Georgia, at the age of 84 years old and was buried in Oak Hill Cemetery.

Haney Turner Nall, daughter of Middleton F. And Louisa Nall, was born in Henry County, Georgia, on July 14, 1832. She was the second wife of Mathew Cole who she married in 1851. In 1847, Mathew first married Emily Woods, who died in 1849 following the death of their infant child. Mathew and Haney remained married until her death on November 18, 1886, at the age of 54. Mathew and Haney had six children—Amanda, Madison Filmore, Robert Duke, Roy Nall, Edwin Marcus, and Frank Bartow. All their sons served in some capacity at the R.D. Cole Manufacturing Company.

Madison Filmore Cole, also known as M.F. Cole, was born on September 13, 1856, in Newnan, Georgia, the second son of Mathew and Haney Nall Cole. He married Bertha May Stewart Cole in 1879. The couple had three children, John Stewart Cole, Christine Cole, and May Cole. Madison worked at the R.D. Cole Manufacturing Company first as a secretary-treasurer then as general manager. Around 1914, Madison sold his stock in the company and became president of the Newnan Cotton Mills, a position he held until his death. Madison died on September 7, 1920, at the age of 63.

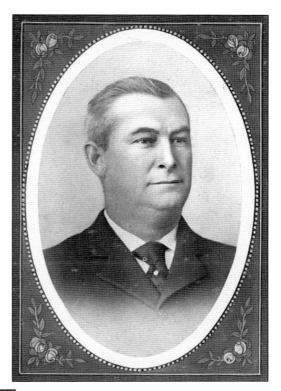

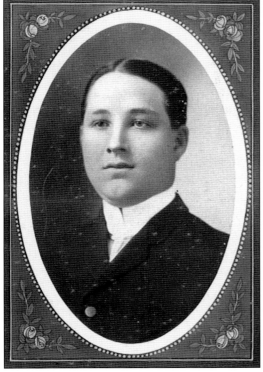

John Stewart Cole, son of Madison Filmore Cole and Bertha May Stewart, was born on January 18, 1882. On October 16, 1917, Stewart married Clifford Powers in her hometown of Houston, Georgia. One year later, in 1918, Stewart was drafted into World War I. Stewart and Clifford lived in Macon, Georgia, and Stewart worked as a junior member of the firm Lee and Cole. Before moving to Macon in 1917, Stewart was associated with R.D. Cole Manufacturing Company as assistant superintendent. Stewart died on July 28, 1923, at the age of 41.

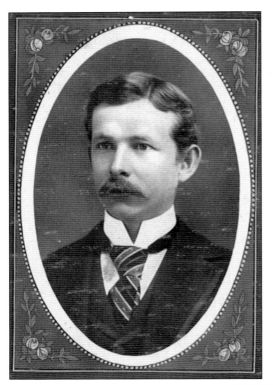

Edwin Marcus Cole, also known as E.M. Cole, was born on February 26, 1859, in Newnan, Georgia. He was the third son of Mathew and Haney Cole. He attended Cornell University in New York, New York, and returned to work at the R.D. Cole Manufacturing Company in multiple facets, including treasurer and manager of the Atlanta office. In 1892, Edwin married Mattie Tate and had four children, Raymond, E.M. Jr., R.D. Cole III, and Martha Tate. Edwin died in Atlanta, Georgia, at the age of 69 on December 2, 1928.

Martha "Mattie" Tate Cole, wife of Edwin Marcus Cole, was the sister of Samuel Tate, founder of the Georgia Marble Company. Edwin and Mattie's home on East Broad Street in Newnan is made from marble. Mattie and her husband are both laid to rest in this marble mausoleum in Oak Hill Cemetery—the only mausoleum in the cemetery. The mausoleum is a simple classic design with eight crypts.

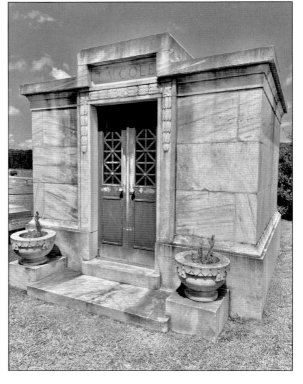

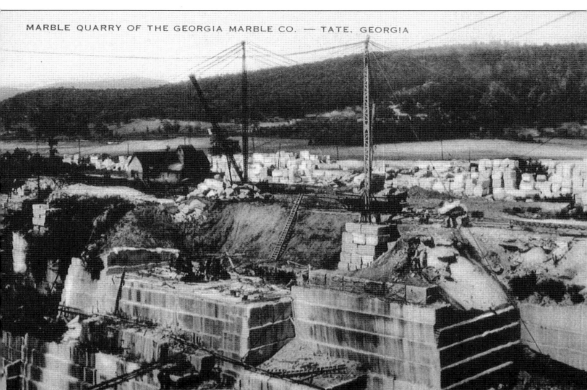

MARBLE QUARRY OF THE GEORGIA MARBLE CO. — TATE, GEORGIA

Samuel Tate founded the Georgia Marble Company in 1884 in Tate, Georgia. The company's mines were known for containing some of the best-quality marble of almost every type in the country. The Georgia Marble Company became the largest employer in Tate and provided its employees with housing, recreational facilities, and schools for their families. Georgia Marble Company stone has been used in public monuments and buildings across the country, including the Lincoln Memorial and the US Capitol in Washington. The Cole family used their family connections with the Tate family to use Georgia Marble Company stone in buildings and homes in Coweta County. This postcard shows a marble quarry of the Georgia Marble Company in Tate, Georgia, in the 1940s.

Frank Bartow Cole (January 5, 1861–April 10, 1945) attended Cornell University but returned home to work at the family business as chief engineer. He married Clara North and had three children, Frank Bartow Cole Jr., Thomas Cole, and Clara Frances Cole. During World War I, Frank worked as a "dollar-a-year man" to help mobilize and manage the American industry. In 1916, Frank sold his shares of the R.D. Cole Manufacturing Company. He remained in Newnan to establish an Oil Distribution Company and was named to the State Personnel Board by Gov. Ellis Arnall.

Roy Nall Cole (April 2, 1867–February 23, 1928) was the youngest child of Mathew and Haney Cole. After studying at Cornell University, he returned to Newnan to work at R.D. Cole Manufacturing Company, first as the company bookkeeper and later as the secretary-treasurer. Roy married Jane "Jennie" Fowler Cole on June 14, 1893. When R.D. Cole Jr., Guy Cole, and Bryan M. Blackburn acquired R.D. Cole Manufacturing Company in 1916, Roy was the only brother to retain his ownership of the company until his death in 1928.

This c. 1869 picture of brothers Frank Bartow Cole (left) and Edwin Marcus Cole is the earliest photograph from the Cole family. Frank and Edwin were toddlers during the Civil War, a time when Newnan served as a "hospital town," housing hundreds of wounded soldiers in churches and homes, and became the site of the Battle of Brown's Mill, which changed the course of Sherman's Atlanta Campaign. (Courtesy of Louise Parham.)

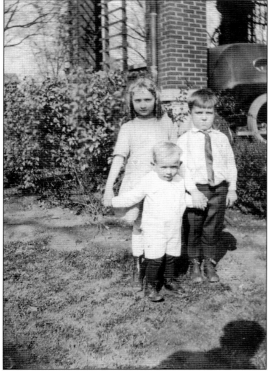

Pictured around 1899 are Ruth Cole, Edwin Cole, and Raymond Cole in front of Frank and Clara Bartow's turn-of-the-century house on East Broad Street in Newnan, Georgia. Ruth is the daughter of R.D. Cole Jr. and Fannie Hill Cole. Both Raymond and Edwin are the children of Edwin Marcus and Mattie Tate Cole. (Courtesy of Minerva Cole Woodroof Winslow.)

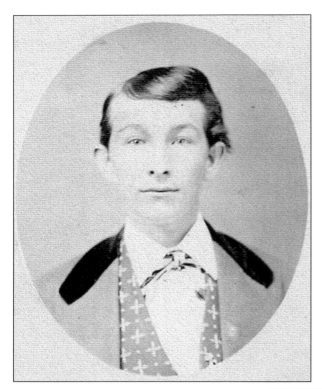

Robert Duke Cole Jr. or R.D. Cole Jr. was born in Newnan, Georgia, on September 28, 1854, as the first and eldest son of Mathew Cole and Haney Nall Cole. He attended private schools in Newnan and finished his studies at the University of Georgia (UGA) in 1872. At the University of Georgia, he participated in several student activities and became a member of the Sigma Chi fraternity. Pictured here is Robert in his senior class photograph at UGA.

After graduation, Robert returned to Newnan to work at the R.D. Cole Manufacturing Company. He worked in several capacities at the organization until he was named president in 1912. Cole served as the second of four presidents of the organization.

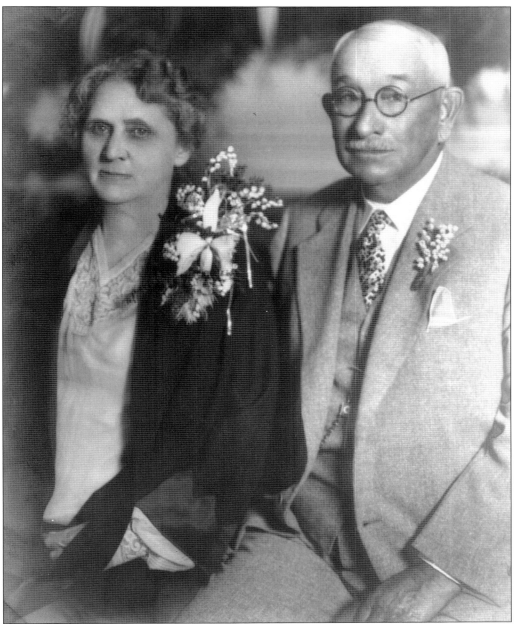

R.D. Cole Jr. (right) married Fannie Hill Cole on November 12, 1878. Pictured is the couple celebrating their 50th anniversary at Central Baptist Church in Newnan, Georgia. The two were a prominent couple in the community. In addition to his role at the R.D. Cole Manufacturing Company, R.D. Cole Jr. was also a Georgia state senator in 1925. He served as vice president of Newnan Cotton Mills, vice president of Manufactures National Bank, vice president of Farmers Warehouse, director of Coweta Cotton Oil Company, director of Atlanta Lowry National Bank, and vice president of Arnco Mills. He was a member of the prestigious Rice Foundation Society and president of the American Boilermakers Association. Cole also served on the Board of Directors of the Atlanta West Point Railroad. (Courtesy of Mathew Pinson.)

Fannie Hill, daughter of Armistead Burt Hill and Mary Corrinne Clark Cole, was born on March 12, 1858. She and R.D. Cole Jr. had three children, Edward Guy Cole, Ruth Hill Cole, and Katheryn Cole. Fannie was an active member of the Central Baptist Church. She held the position of president of the Friday afternoon Bible study class for over 17 years. R.D. Cole Jr. died on January 27, 1942, and Fannie Hill Cole died December 24, 1943. Both are buried in Oak Hill Cemetery in Newnan, Georgia. (Left, courtesy of Minerva Cole Woodroof Winslow; below, courtesy of Mathew Pinson.)

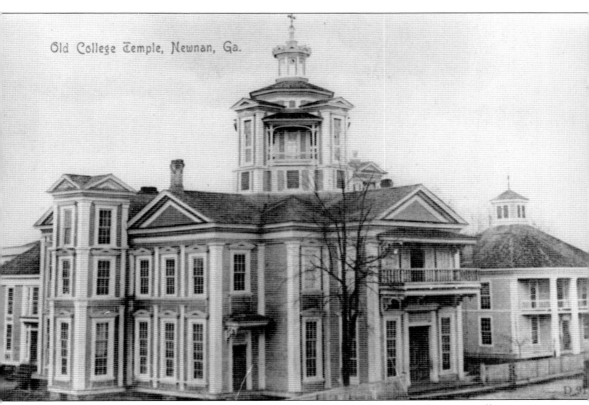

Fannie Hill attended College Temple in Newnan, Georgia. College Temple was an all-women's college located in Newnan, Georgia, founded in 1853 by Moses Payson Kellogg. College Temple opened with the mission to "elevate women" and "promote Southern female authorship." College Temple was most known for being the first college in the country to grant women a Master of Arts degree. Fannie received a Master of Arts degree from the school in 1876. College Temple closed in 1889. (Courtesy of the Newnan-Coweta Historical Society.)

Edward Guy Cole, affectionately known as Guy, was born in Newnan on August 31, 1880, to Robert Duke and Fannie Hill Cole. Guy graduated from Newnan High School in 1897 and attended Georgia Institute of Technology. He transferred to the Massachusetts Institute of Technology in Boston and, in 1903, graduated with a degree in mechanical engineering. After graduating, he returned home to work at the family company where he served in several capacities and succeeded his father as president in 1942.

In addition to his duties at the family company, Guy Cole was also a director of Arnco Mills, director of Newnan Cotton Mills, director of the Manufacturers National Bank, and director of Newnan Building and Loan Association. He was a member of the prestigious Rice Foundation Society and served on the Board of Directors of the Atlanta West Point Railroad. (Courtesy of Minerva Cole Woodroof Winslow.)

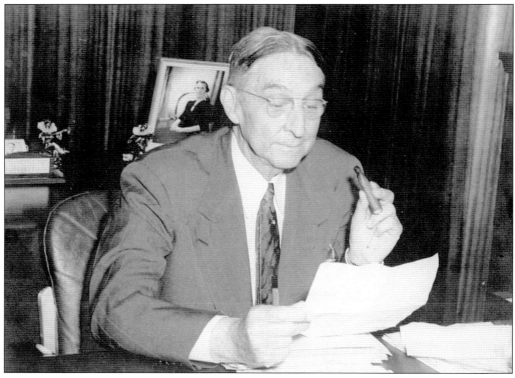

On June 28, 1904, Guy Cole married Minerva Fort Hunter. The couple (pictured at right) had five children and were active members of the local community. Guy died on March 11, 1958, at the age of 77. His wife, Minerva, died five years later on January 14, 1963, at the age of 80. This photograph shows the couple in their older age. (Courtesy of Minerva Cole Woodroof Winslow.)

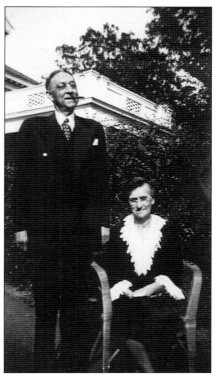

Guy Cole is pictured here around 1944 with his family. He is seated at center with Charles Woodroof Jr. on his lap. Standing behind Guy are, from left to right, Frances Cole Arnall, Hamilton C. Arnall, Minerva Fort Hunter Cole, Susan Hunter Arnall, and Minerva Cole Woodroof. To the left of Guy are, from left to right, Dollie Hunter Arnall, Suzanne Cole Jones, and Hamilton Arnall. To the right of Guy are, from left to right, Otis Fleming Jones Sr., Annie Jones, Otis Fleming Jones Jr., and Guy Arnall. Not pictured are Edward Guy Cole, Raleigh Arnall, and Charles Brannen; they were serving overseas in World War II at the time. (Courtesy of Minerva Cole Woodroof Winslow.)

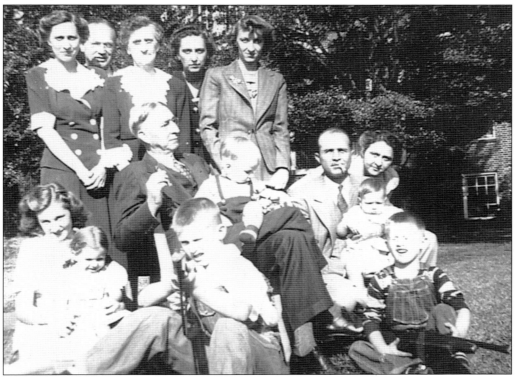

Bryan Martin Blackburn, pictured here at the age of three years old, was born in Madison, Georgia, on August 25, 1884. His father was Benjamin Milner Blackburn, and his mother was Antionette Martin Blackburn. Bryan grew up in the Atlanta area, attending preparatory school at the Peacock School for Boys and public school in Atlanta.

Ruth Hill Cole Blackburn was the only surviving daughter of Robert Duke Cole Jr. and Fannie Hill Cole. She was born on December 21, 1887. Ruth gained local fame for her soprano singing voice. She was often featured in local events, including a recording of Newnan talent in 1924 for WSB, the *Atlanta Journal* broadcasting station.

This photograph shows Bryan Martin Blackburn as a student at Georgia Institute of Technology in 1903. The lapel pin is one of the Skull and Key fraternity at Georgia Institute of Technology. After graduating from college, Bryan M. Blackburn moved to Newnan in February 1905 to work at R.D. Cole Manufacturing Company. He was widely known for his keen sense of business and his contributions to both religious organizations and his community.

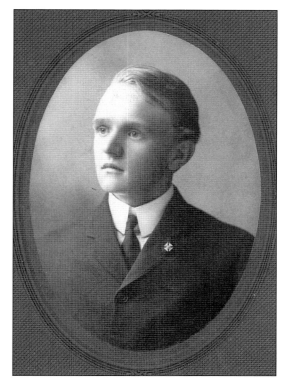

Bryan M. Blackburn married into the Cole family by way of Ruth Hill Cole. The couple married on April 28, 1910. They had three children, Fannie Cole Blackburn (Sargent), Ruth Cole Blackburn (Hammett), and Duke Cole Blackburn Sr. Ruth Hill Cole is photographed here in her wedding gown.

Edward Guy Cole (right) and Bryan Martin Blackburn met while attending Georgia Institute of Technology in the 1890s. Edward Guy transferred and finished his degree at the Massachusetts Institute of Technology in Boston. Bryan remained at Georgia Tech and graduated with a mechanical engineering degree in 1904, then pursued a master's degree. Blackburn began working at R.D. Cole Manufacturing Company in 1905 in the engineering department, eventually rising to secretary-treasurer and holding a primary partner ownership in the company. R.D. Cole Manufacturing Company held several patents for water tanks designed by Blackburn. Cole and Blackburn worked together in the company for over 50 years. When Blackburn married Cole's sister in 1910, the business partners also became brothers-in-law.

Three

A Period of Growth

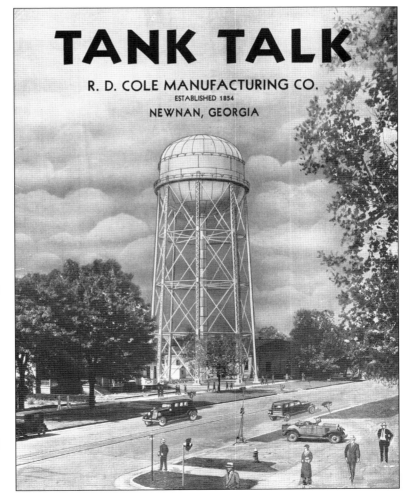

Gradually over the years from 1904 to 1963, the R.D. Cole Manufacturing Company expanded its line of products and became one of the leading fabricators of elevated tanks and towers, standpipes, and gas holders and leading manufacturers of steel, alloy steel, and aluminum vessels of all kinds for industrial purposes.

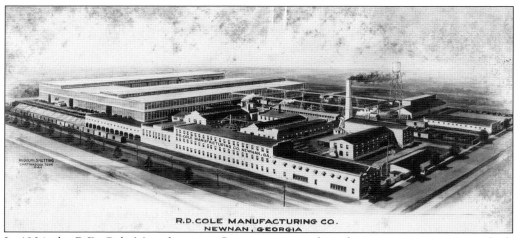

In 1904, the R.D. Cole Manufacturing Company renewed its charter as a corporation, which identified the purpose of the company as manufacturing, building, contracting, and repairing a wide variety of machinery and farming equipment. Throughout the mid- to late 1900s, however, the R.D. Cole Manufacturing Company would focus its specialization and concentrate primarily on the development and construction of water tanks. This artistic rendering of the R.D. Cole Manufacturing Company in 1944 shows the growth and technological development of the company's campus.

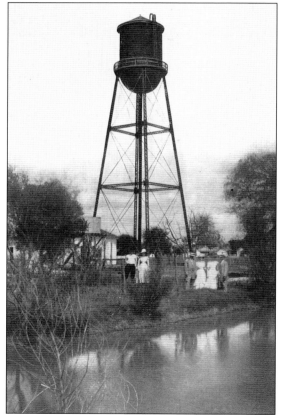

By 1869, the first transcontinental railroad had been completed, and by 1900, the nation had 193,000 miles of track with five railroad systems. The R.D. Cole Manufacturing Company depended upon the railroad system to transport its equipment and product across the country. This 94-foot-tall 50,000-gallon water tank was erected by the R.D. Cole Manufacturing Company in Forney, Texas, for the Forney Water Works Company.

R.D. Cole Sr. died on June 1, 1910, at the age of 89; both his wife, Martha, and his brother Mathew preceded him in death. The town of Newnan shut down for a day to say goodbye to the grand old man known as "Uncle Duke."

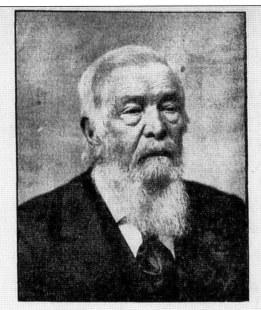

R. D. COLE, Sr., Newnan's "Grand Old Man," who died Wednesday night, aged 89.

After an illness of ten days the spirit of Mr. R. D. Cole, sr., Newnan's first citizen, passed from earth to a better world Wednesday night at half-past 10 o'clock—aged 89 years and 5 months

tant of this self-control was action based on conviction. His was not a fickle, vacillating nature. Temporary expedients were not of his creed. He

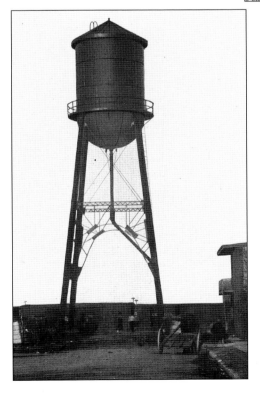

By the time of R.D. Cole Sr.'s death, the company had built around 590 tanks and standpipes and sold more than 4,000 steam engines. The company had become the second-largest elevated water tank manufacturer in the United States. Highlighted here in a 1911 company catalogue is one of the company's 50,000-gallon tanks with a special portal bracing design, located at a cotton warehouse in Augusta, Georgia.

51

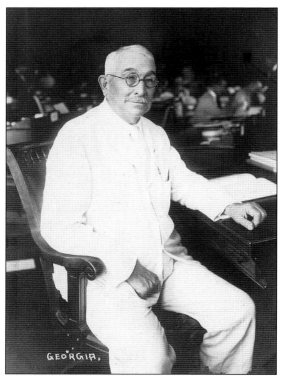

Seated at his desk is state senator R.D. Cole Jr. at the state capital in Atlanta, Georgia, around 1925. After his uncle's death, R.D. Cole Jr. became president of the R.D. Cole Manufacturing Company. In 1916, R.D. Cole Jr. acquired controlling interest in the R.D. Cole Manufacturing Company. (Courtesy of Mathew Pinson.)

Though their husbands ran the business, the wives were also leaders in the community. Pictured in the 1920s is Fannie Hill Cole, wife of R.D. Cole Jr., with her granddaughters. Pictured around Fannie Hill Cole are, from left to right, Susan, Annie, Ruth, Fannie, and Frances. Fannie expressed her love for family saying, "They have given me great entertainment and true love and kindness." (Courtesy of Mathew Pinson.)

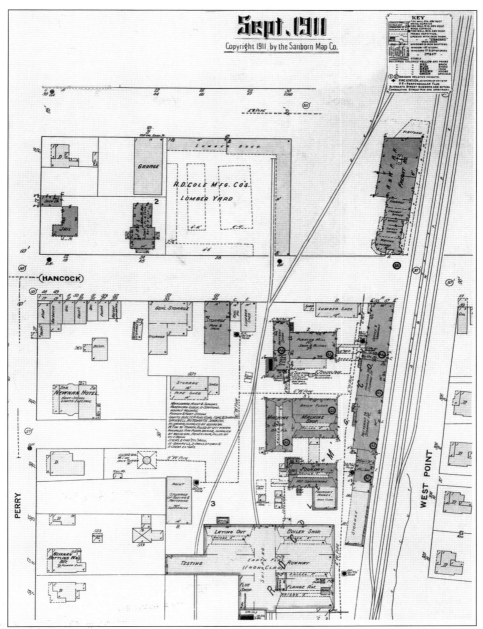

Originally published throughout the 19th and 20th century by the Sanborn Map Company, Sanborn maps were created of urban areas for the purpose of allowing fire insurance companies to assess their total liabilities. This 1911 Sanborn Map shows the layout of the R.D. Cole Manufacturing Company at the time that R.D. Cole Jr. became president. The main building with the offices was a large brick structure located near the railroad. Next, the company had a storage warehouse and an erecting room for cornmills and sawmills. Farther back on campus was the department where standpipes, smokestacks, towers, and tanks were fitted together. The foundry adjoined the large boiler shop. The machine shop, planing mill, gristmill, and flour mill completed the main campus with the lumberyard located across the street.

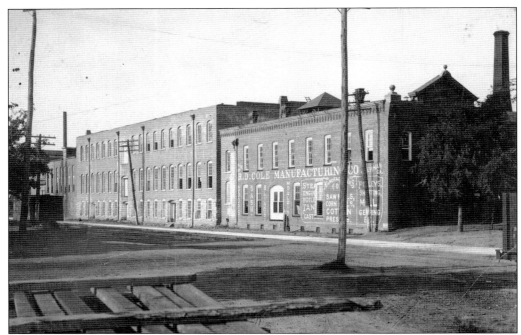

This photograph, taken from across the railroad tracks in downtown Newnan, shows the facing of the R.D. Cole Manufacturing main office building. It was a large brick structure that stood two stories high in the front and three stories high at the rear with 400 feet of railroad frontage.

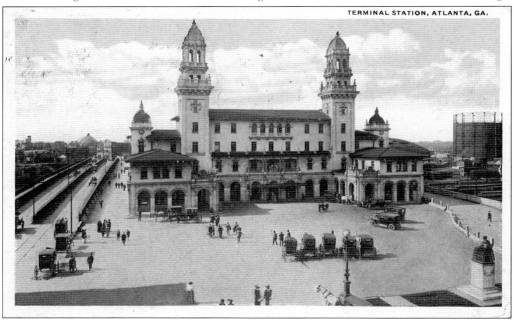

Terminal Station in downtown Atlanta was the larger of two principal train stations in the area. The station opened in 1905 and served Southern Railway, Seaboard Railway, Seaboard Air Line, Central of Georgia, and the Atlanta & West Point (A&WP) Railroad. Three generations of Cole family members served on the Board of Directors of Terminal Station of A&WP Railroad.

While still highly agriculturally based in the 1920s, Coweta began integrating and expanding its technology and saw a manufacturing boom during the decade. This photograph of downtown Newnan in the 1920s shows the R.D. Cole Manufacturing–produced streetlights. The building in the foreground housed WCOH Radio—Welcome City of Homes—on the top floor at the time. (Courtesy of the Newnan-Coweta Historical Society.)

Roy Nall Cole passed away at his Florida home in St. Petersburg on February 23, 1928, surrounded by his wife and his wife's orphan niece, Dorothy Gardner Ford. Pictured is a 500,000-gallon water tank built for Roy Nall Cole's second hometown of St. Petersburg. The tank features a special design tower and stairway.

Photographed is Thomas Kellam "T.K." Barron, one of the first non-Cole family members to earn a leadership position at the R.D. Cole Manufacturing Company. Barron worked for the company from September 1918 to November 1960. He started his career as a shipping and voucher clerk and worked his way up through positions, such as payroll master, to become executive secretary and keeper of the seal and stock book in 1928. (Courtesy of Katie Barron Brady.)

Here, the R.D. Cole Manufacturing Company float, parked on College Street, is waiting for the start of the 1927 Coweta County Centennial Parade. On the float are, from left to right, R.D. Cole Jr., Duke Cole Blackburn Sr., Edward Guy Cole Jr., and Thomas Kellam "T.K." Barron (driver). (Courtesy of Katie Barron Brady.)

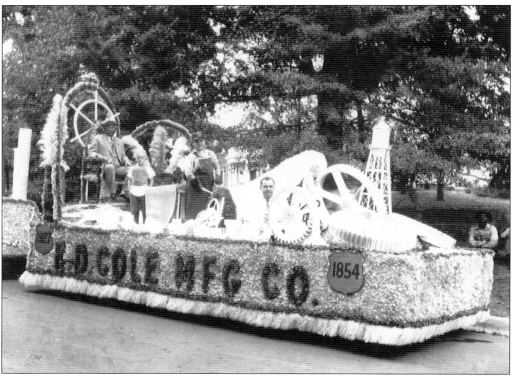

Pictured is Harry C. Fisher, the former mayor of Newnan and director of the Atlanta & West Point Railroad. Fisher, along with R.D. Cole Jr., Guy Cole Jr., and other prominent businessmen, were founding members of the Newnan Board of Trade, developed in 1890. The purpose of the organization was "to foster and develop the mercantile and manufacturing interest of Newnan and its suburbs," as written in the *Newnan Herald and Advertiser*.

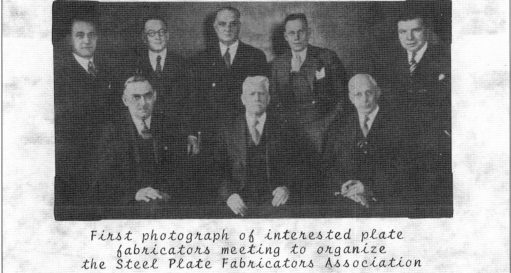

First photograph of interested plate fabricators meeting to organize the Steel Plate Fabricators Association

The Cole family believed in getting involved in organizations for improvement of industrial manufacturing and often held board positions. These organizations included Newnan Land Company; American Boilermakers Association; Savannah Board of Trade; Georgia, Inc.; and the prestigious Steel Plate Fabrication Association, which was started to meet the requirements of Pres. Franklin D. Roosevelt's National Recovery Act. This is the first photograph of interested plate fabricates meeting to organize the Steel Plate Fabricators Association in 1933. Bryan Blackburn was a founding member but is not pictured here.

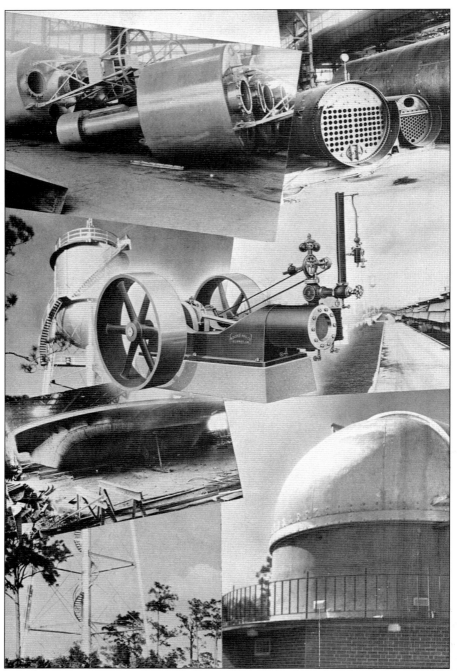

Throughout its existence, the R.D. Cole Manufacturing Company was active in every American war effort, participating largely in the defense program. During the Civil War, rolling stock was repaired and built. During the Spanish-American War, boilers, stacks, and other materials were supplied to the government. During World War I, the company constructed ship parts as part of Emergency Fleet Corporation efforts. Photographed is a collage of equipment constructed by the company for wartime efforts presented in its 1954 Centennial Celebration booklet.

During World War II, the R.D. Cole Manufacturing Company dedicated 100 percent of its efforts to the Maritime Commission for the construction of prefabricated ship parts for the Victory Ship Program. The R.D. Cole Manufacturing Company manufactured the masts, king ports, stanchions, and deck equipment needed to construct the ships. Photographed to the right is a World War II US Navy cargo ship loading supplies. Below is a World War II Victory ship similar to those with components constructed at the R.D. Cole Manufacturing Company.

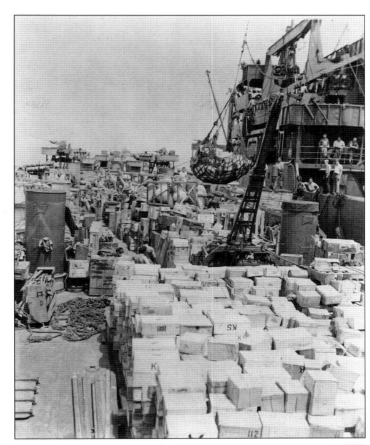

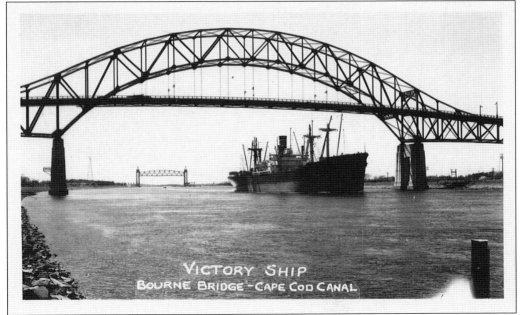

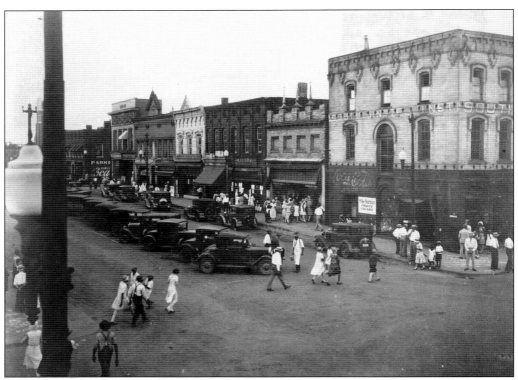

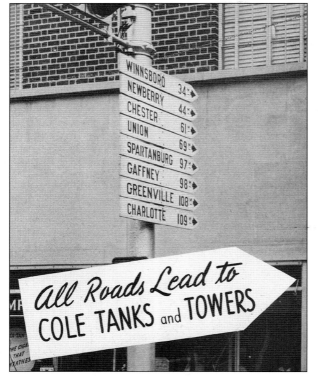

The world's population reached two billion in 1927, necessitating better technology and practices for natural resources like safe water and water systems. The R.D. Cole Company was one of many companies participating in the private water industry throughout the 19th and 20th century. This photograph of Newnan in the 1920s shows the hustle and bustle of downtown during the world's second population boom.

In 1939, the R.D. Cole Manufacturing Company erected an ellipsoidal 137,000- gallon tank for a contract of $122,840 in Charlotte, North Carolina, as part of the city's new water system. The company was one of fifty companies contributing to the project. Photographed is a R.D. Cole Manufacturing Company advertising around 1940 stating that all roads lead to Cole Tanks and Towers. Charlotte is shown as a featured city.

Throughout the 1930s and 1940s, the R.D. Cole Manufacturing Company designed and built a complete line of tanks ranging in capacity from 5,000 gallons to 2,000,000 gallons of water. The company designed tanks of all types from standard hemispherical shape to specialty tanks for advertising purposes. Pictured on the right is the proposed drawing for a water tank modeled after a Chero-Cola bottle. The 40,000-gallon Chero-Cola water tank is shown fully built below.

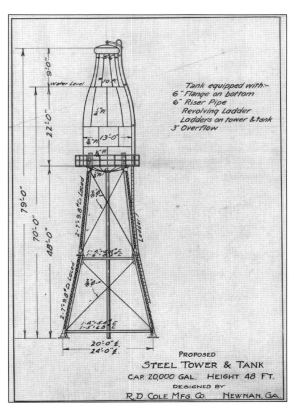

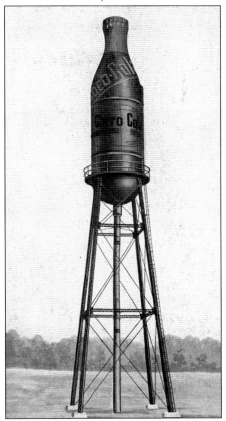

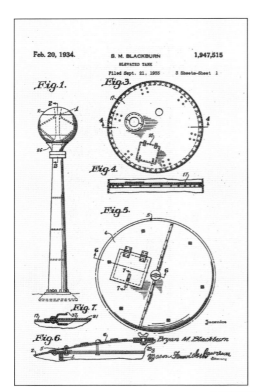

On February 20, 1934, the US Patent Office granted R.D. Cole Manufacturing Company engineer and designer Bryan M. Blackburn the patent to a 100,000-gallon spherical tank with a tubular tower. The water tank famously gained the name of "golf ball" water tank. Pictured to the left is the mechanical drawing of the golf ball water tank. Pictured below is this type of tank erected by the company for Emory University in Atlanta, Georgia.

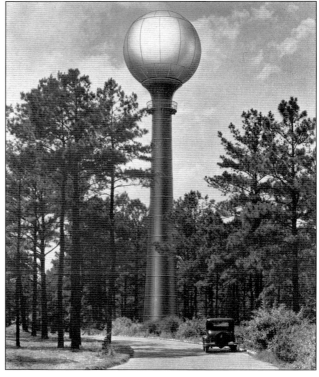

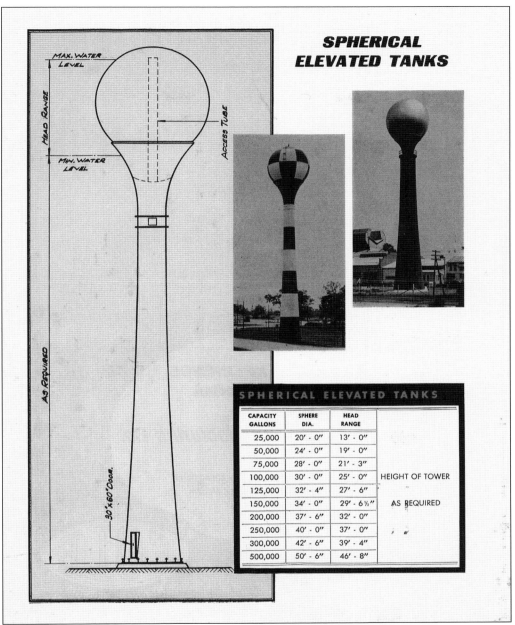

This page in an R.D. Cole Manufacturing Company promotional magazine depicts the specifications of the company's spherical elevated tanks. Photographs of completely erected water tanks accompany the drawing. The spherical evaluated tank was one of two original water tank designs engineered by Bryan Blackburn and patented by the R.D. Cole Manufacturing Company. (Courtesy of the Newnan-Coweta Historical Society.)

Photographed is Bryan Blackburn working at this desk around 1940. Bryan Blackburn was the R.D. Cole Manufacturing Company's chief engineer. The framed photograph of Ruth and her children on his desk is the same image shown below. Family remained a consistent priority for the Cole family, and their success can be attributed to this focus. (Courtesy of Julia Victoria Blackburn Owens.)

Photographed is Ruth Hill Cole (Blackburn) along with her and Bryan's children Fannie Cole Blackburn (standing left), Ruth Cole Blackburn (standing right), and Duke Cole Blackburn Sr. (seated). Prior to marrying, Ruth attended Fairmont College in Washington, DC.

Designed and patented by Bryan Blackburn in the 1940s, the Ovaloid tank had a large capacity of up to 2,000,000 gallons of water. This ovaloid tank, photographed in 1954, was erected in Leakesville, North Carolina.

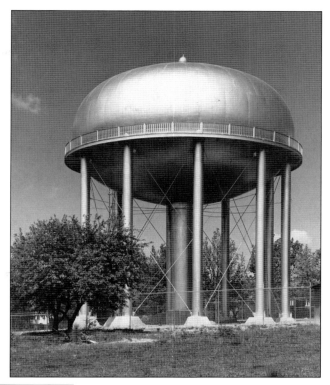

Bryan Blackburn became associated with the R.D. Cole Manufacturing Company in 1905 and worked at the company until his death in 1955. Pictured is Bryan Blackburn standing on the driveway of his home on East Broad Street in Newnan, Georgia.

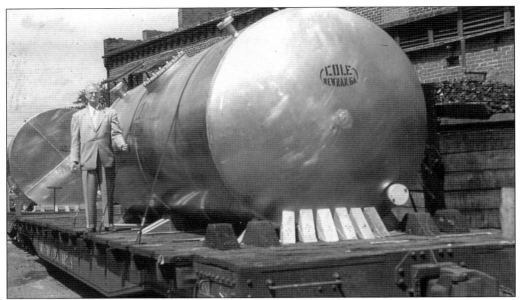

In addition to elevated tanks, the R.D. Cole Manufacturing Company specialized in fuel oil strong tanks, oil and water storage tanks, acid tanks, vats, chemical tanks, storage bins, stacks, and all forms of fabricated steel plate construction. The company manufactured special equipment for the processing industry, such as alloy steel plates, stainless steel, nickel-clad steel, and vessels lined with aluminum, tin, nickel, or zinc. Pictured is an employee standing next to an aluminum chemical vat designed and made at R.D. Cole Manufacturing Company.

R.D. Cole Jr. died in 1942. He was a friendly and familiar face to hundreds of Coweta County citizens, and his manufacturing business brought him friends throughout the United States. R.D. Jr. (left) is shown on a fishing trip during his older years with his companion Robert Stallings.

Edward Guy Cole Jr., born February 16, 1917, is the son of Edward Guy Cole and Minerva Fort Hunter Cole. Ed graduated from Georgia Tech with a business degree. After graduation, he returned to Newnan to work as the vice president of the R.D. Cole Manufacturing Company. In 1940, Edward was drafted into the Army during World War II, becoming the seventh generation to serve since the American Revolution. Ed was on the board of trustees for the Manufacturers National Bank, American Boilermakers Association, and the Steel Plate Fabrication. He was a deacon at Central Baptist Church.

Pictured are Edward Guy Cole and his wife, Edwana Eby, daughter of Dr. Joseph D. Eby and Julia Rosser Eby of New York. The couple is photographed here at the company's centennial celebration. They married in 1936 and had two children, Edward Guy Cole III and Julie Eby Cole.

Duke Cole Blackburn, son of Bryan Martin Blackburn and Ruth Hill Cole Blackburn, was born July 2, 1919, in Coweta County, Georgia. At 21, Duke was drafted into the Army, serving during World War II. In 1955, Blackburn was called to serve as the lieutenant colonel on the staff of Georgia governor Marvin Griffin.

Julia Leah Attaway Blackburn was born to Newnan-natives Carl Olin Attaway and Rosa Lee Walker Attaway on October 5, 1923. She married Duke Cole Blackburn Sr. and had three sons, Duke Cole Blackburn Jr., Bryan Martin Blackburn II, and Robert Mathew Blackburn. Julia Blackburn was known as an avid gardener and an active member of her community. She was a member of the Central Baptist Church of Newnan and the Driftwood Garden Club and Newnan Junior Service League. She passed away on June 29, 2001, in her hometown of Newnan, Georgia.

Pictured is Duke Cole Blackburn Sr. standing by a water tank model in 1941. Duke Cole Blackburn Sr. served as vice president of the R.D. Cole Manufacturing Company. He was an active member of this community serving as founding director of C&S Bank in Newnan and a member of the Newnan Hospital Board, the Margaret Mitchell Safety Council, the chamber of commerce committee, and the Coweta Cattlemen's Association. He died on January 2, 1990, at the age of 70.

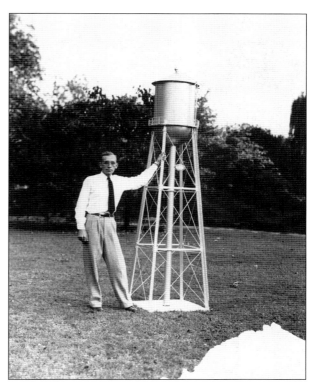

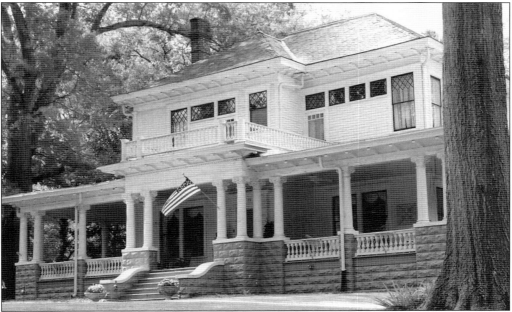

Pictured is the home on R.D. Cole Jr. and Fannie Hill Cole on East Broad Street in Newnan, Georgia. Bryan Blackburn and Ruth Blackburn also lived in this home. Descendants of the Cole family still live in the Coweta County area and are active, impactful members of the local community carrying on the legacy of the Cole family.

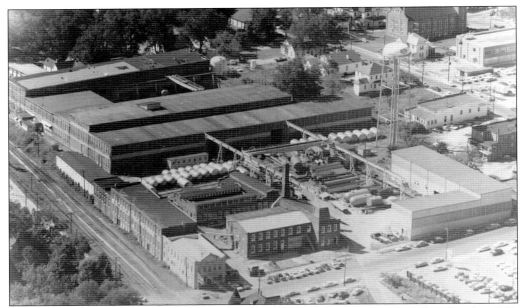

These 1950s aerial pictures of the R.D. Cole Manufacturing Company campus (above) and an R.D. Cole water tank in Newnan demonstrate the growth of the company during the 20th century. By mid-century, the company was one of the leaders in the design of water tanks, standpipes, and gas holders, as well as a leader in the manufacturing of steel, alloy steel, and aluminum steel.

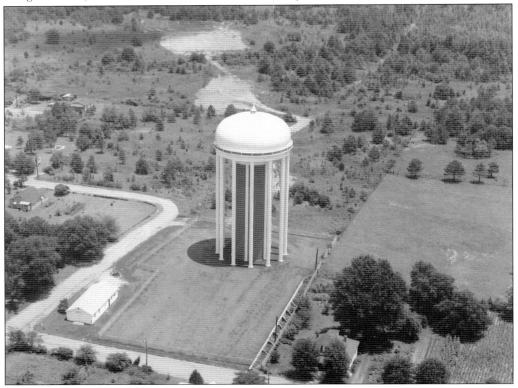

Four
IMPACT ON THE LOCAL COMMUNITY

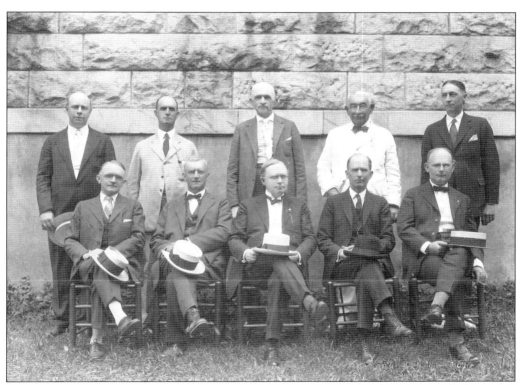

Pictured in the 1930s are deacons from Central Baptist Church who also often worked together professionally and served on business boards. From left to right are (seated) Bryan Blackburn, T.G. Farmer Sr., H.A. Hall, Charles Barron, and H.C. Arnall Jr.; (standing) John Kersey, Howard C. Glover, W.A. Steed, R.D. Cole Jr., and E.G. Cole. All were prominent businessmen of Coweta County. (Courtesy of Mathew Pinson.)

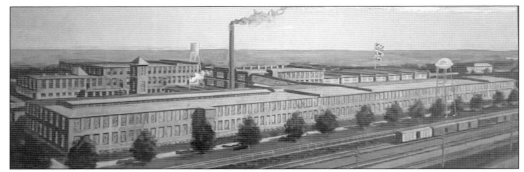

R.D. Cole Sr. was instrumental in the founding of the Newnan Cotton Mills in 1888. The petition for the charter was posted by R.D. Cole Sr., N.B. Glover, H.C. Arnall, R.H. Hardaway, T.W. Powel, U.B. Wilkinson, J.F. Lovejoy, J. Reese, and H.J. Sargent. They associated with approximately 107 local investors, who gave funds to start the mill and became stockholders. These men created the company to manufacture yarn, cloth, and other materials, like rope used at the R.D. Cole Manufacturing Company for producing sash windows. R.D. Cole Sr. served as the first president of the mill until his death in 1910. Above is an artistic rendering of the Newnan Cotton Mills No. 1 campus. Below is the Edwin Marcus and Mattie Tate Cole home, which later served as the home of Karl Nixon and his wife, Mary Glover Nixon. Karl Nixon was a president of the Newnan Cotton Mills. (Above, courtesy of the Newnan-Coweta Historical Society.)

Madison "Matt" Filmore Cole is pictured on the Downtown Newnan Square. He was the son of J. Stewart Cole and Clifford Power and grandson of Madison Filmore Cole. Matt was raised in Macon, Georgia, and excelled in school and Boy Scouts of America, earning his Eagle Scout badge. After graduating from Georgia Tech, he returned to his father's hometown of Newnan and worked at the Newnan Cotton Mills, rising to general manager. He later worked in the insurance business.

Around 1925, the Central of Georgia Railway produced a promotional booklet, titled "Textile Opportunities in the South." The publication listed several prominent textile developments in the Newnan area, including 58,000 spindles at Newnan Cotton Mills. The booklet summary noted that "cheap and abundant power, excellent climate, adequate transportation facilities, local cooperation and an abundance of native American labor, all located in the heart of the Cotton Belt of the Southeast, are the advantages that Newnan offers to anyone contemplating textile developments in the South." (Courtesy of the Newnan-Coweta Historical Society.)

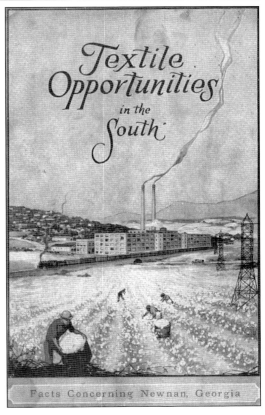

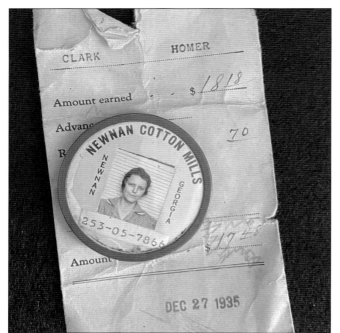

This Newnan Cotton Mill identification badge from the 1930s, donated to the Newnan-Coweta Historical Society by Tina Lucas, once belonged to Homer Clark. Clark was a single woman who worked at the Newnan Cotton Mills and lived nearby in downtown apartments. Clark's full name was Homer Clara Dana Jackson Georgia Martin Byrd Clark. (Courtesy of the Newnan-Coweta Historical Society.)

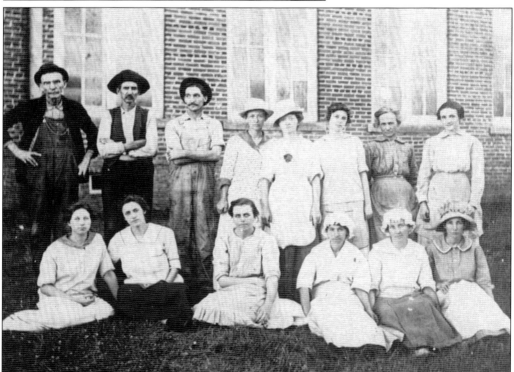

Photographed are workers of Newnan Cotton Mill in 1916. Nettie Crawford is pictured on the front far right, and Hattie Crawford is photographed on the back far right. The names of the other workers in the photograph are unidentified. (Courtesy of the Newnan-Coweta Historical Society.)

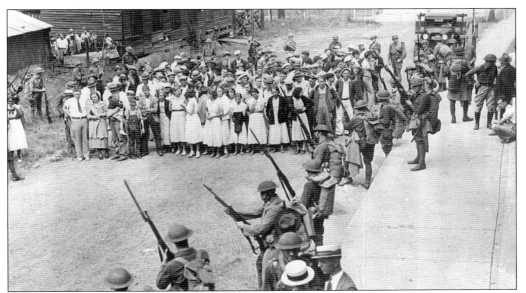

Pictured are mill workers on strike facing the US National Guard at the Newnan Cotton Mill during the General Textile Strike of 1934. Workers across the country began a strike to protest their treatment by the owners and executives of the mills. Some of the first strikers arrested worked at the East Newnan Cotton Mill and nearby Arnall Mills in Sargent. To preserve order during strikes, Governor Talmadge ordered martial law with the National Guard's "flying squadron" responding.

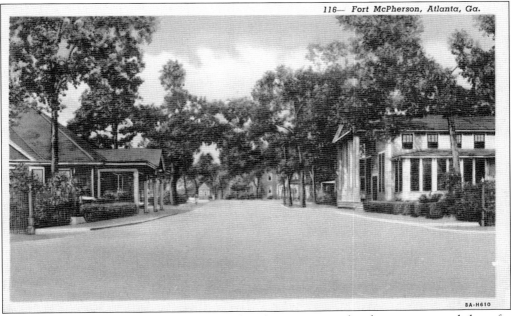

The Georgia National Guard and local civil authorities arrested picketers, inspected them for weapons, and transported them in military trucks to detention camps at Fort McPherson outside Atlanta. The military camp's fire station and service club are shown in this 1930s–1940s postcard of Fort McPherson. Despite the widespread strikes, it should be noted that the workers at the R.D. Cole Manufacturing Company never joined a union, nor did they ever strike.

Pictured is what remains of the Arnall Mills in Sargent, Georgia. The mill was originally founded by Capt. J.H. Sargent, George Sargent, and Col. J.B. Willcoxon in 1866 as the Willcoxon Manufacturing Company. At this time, the R.D. Cole Manufacturing Company purchased rope from the mill for the manufacturing of sash windows. In 1889, the company became Wahoo Manufacturing with Henry C. Arnall Sr. and Thomas G. Farmer as proprietors. By 1919, the Arnall family had acquired full ownership of the mill, and the name was changed to Arnall Mills with Alton Wynn Arnall as president followed by Ellis H. Peniston.

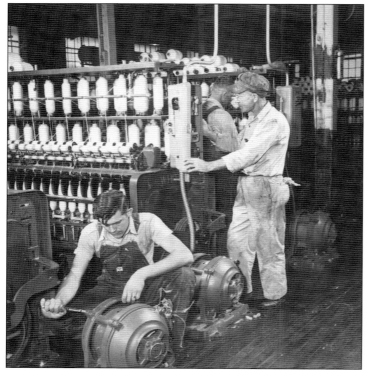

This 1951 photograph shows master mechanic Marvin L. Holloway (standing) and James E. Jones (sitting) working on a spinning frame at Arnall Mills in Sargent. The other man (standing with his back toward the camera) is Roy Hinesly. (Courtesy of the Newnan-Coweta Historical Society.)

These pay envelopes from Arnall Mills from 1950 and 1959 show a week's worth of pay for mill workers Ray and Lillian Gilley. Money was taken out of the employee's salary for various items, like rent for living in the mill village. The husband and wife both began working at Arnall Mills in 1943. Ray worked there seven years until his death in 1950. Lillian worked at the mill until her retirement in 1977. (Both, courtesy of the Newnan-Coweta Historical Society.)

SEP 1·6 1950

ARNALL MILLS
SARGENT, GA.

Name *Gilley Ray*

Earned

	40	Hrs.	41.60
9-9-50		Hrs.	3.60
			45.20

Withholding Tax		10
Bal. Forw'd		
Mdse.		2.89
Fuel		
H. Rent	9.00	5.00
Cash Adv.		
Dr. Tax		
Group Ins.		34
Old Age Ben.		68

Cash Enclosed __ 35.19

Balance Due __

Received amount above stated

APR 4 1959

ARNALL MILLS
SARGENT, GA.

Name *Gilley, Lillian*

Earned

	39¾	Hrs.	51.55
		Hrs.	

Federal Tax	4 70
FICA Taxes	1 29
Group Ins.	1 12
House Rent	2 25
Dr. Elliot	
Bal. Forw'd.	
Fuel *Elec*	4 70
Cash Advance	
Mdse. Store	5 47

Cash Enclosed __ 32.02

Balance Due __

Received amount above stated

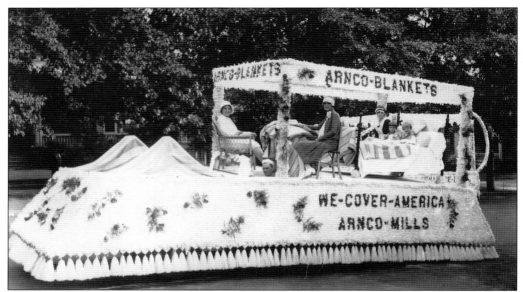

By 1926, the demand of Arnall Mill necessitated construction of Arnco Mill, located nearby in Newnan. The mill was named after Alton W. Arnall and R.D. Cole Jr.—the mill proprietors and president and vice president, respectively. Arnco Mill manufactured and sold blended blankets as advertised on its float in the 1928 Centennial Parade in Newnan. Photographed on the float are, from left to right, Myrtle Arnall Mann, Ruth Moncriff Arnall, Katie Arnall, and Minerva Cole. The male driver and young child are unidentified.

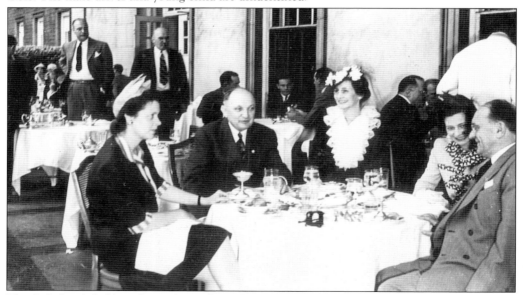

The Cole family held stock in other mills, including the Grantville Hosiery Mill and the McIntosh Mill. Pictured here is Bryan Martin Blackburn (seated at far right) dining with president of the Grantville Hosiery Mill, William Nathaniel Banks Sr. (seated near center). Established in 1896–1897, the Grantville Hosiery Mill manufactured yarn and hosiery in Grantville, Georgia. Blackburn served on the Board of the Grantville Cotton Mills from 1939 until his death in 1955. Madison Filmore Cole had previously served on the board of directors.

Pictured are two labels from Georgia-grown produce. Peaches and cotton were two main agricultural commodities in the state, and the farmers needed fertilizer. The Coweta Fertilizer Company was founded in 1885 with R.D. Cole Sr. as one of the directors. Around 60 businessmen bought stock in the company. The company became one the largest manufacturers and sellers of commercial fertilizer, selling with a profit to the Virginia Carolina Chemical Company in 1898.

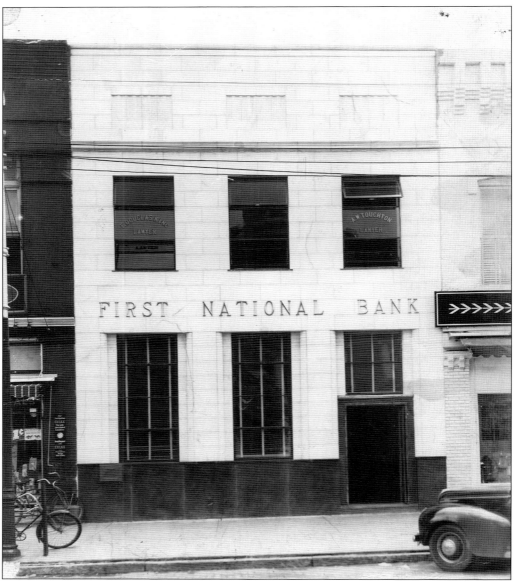

The Cole family oversaw their assets from creation to reinvestment. Several members of the family served as board members of banks in both the Newnan and Atlanta area. Madison Filmore Cole served as director of the First National Bank of Newnan. R.D. Cole Sr. served as the first vice president of the Manufacturers National Bank upon its organization in 1906 and also served on the Board of the Newnan Banking Company. Edwin Marcus Cole also served on the Board of the Manufacturers National Bank. The First National Bank in Newnan, Georgia, is pictured here around the 1920s or 1930s.

Here is a postcard from the late-1910s depicting the Fourth National Bank in downtown Atlanta, Georgia. The bank was designed by the Bruce and Morgan firm and built in 1904 on the corner of Marietta and Peachtree Streets. Edwin Marcus Cole, Roy Nall Cole, and Frank Bartow Cole were members of the Board of Directors for the Fourth National Bank in Atlanta.

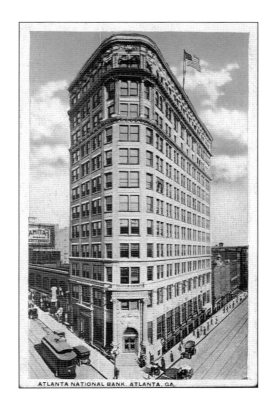

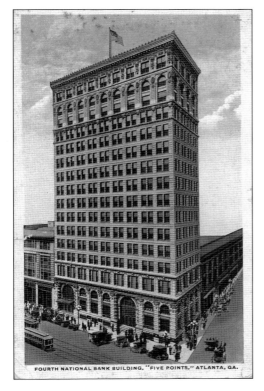

The Atlanta National Bank was federally chartered in September 1865. The bank first opened in the home of Pres. Alfred Austell as the proposed headquarters was burned during the Civil War. By 1911, the bank was located at the corner of Whitehall and Alabama Streets in Atlanta, Georgia, depicted in this c. 1920 postcard. By 1929, the company had merged with several other banks to form the largest bank in the United States south of Philadelphia. R.D. Cole Jr. was a member of the board.

81

Listed as some of the founding members of the Featherston Fishing Club were R.D. Cole Jr., Edwin Marcus Cole, Madison Filmore Cole, Frank Bartow Cole, and Bryan Blackburn. Founded in 1910, the club consisted of 200 acres with a 25-acre pond named "Wynn's Pond" and a clubhouse. Some of the Cole family members are stockholders in this club today. Pictured after an enjoyable day of fishing is Ruth Cole Blackburn. (Courtesy of Robert Mathew Blackburn.)

Pictured is the Newnan Country Club, organized in 1919 with R.D. Cole Jr. as its first president. Coweta County by this time had many successful businessmen who contributed to the founding of this club. Many ladies in Coweta County, including Clara North (Frank Bartow) and Mattie Tate Cole (Edwin Marcus), were elected as members of the governing board.

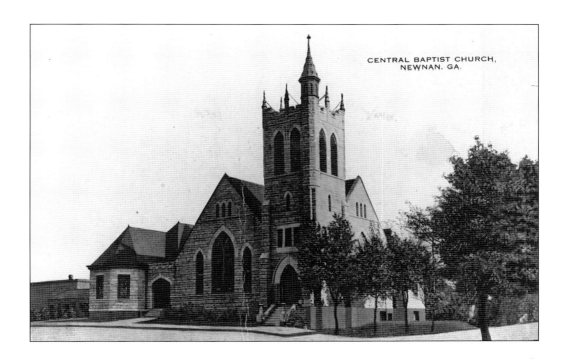

Pictured above is the exterior of Central Baptist Church, built by R.D. Cole Manufacturing Company in 1897. R.D. Cole Sr. and his wife, Martha, along with other members of the Cole family, helped organize Central Baptist Church. All the beautiful timber framing inside the church was molded and made at the Cole Shop. The marble used for building the church was Tate marble from the Georgia Marble Company. Today, the Cole family is still involved with the church, and some members serve as deacons or in other various capacities. Pictured below is the interior of the sanctuary, which shows some of the intricate molding.

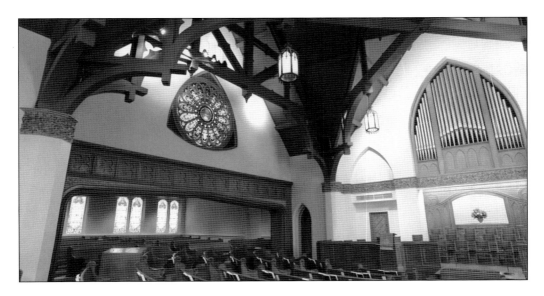

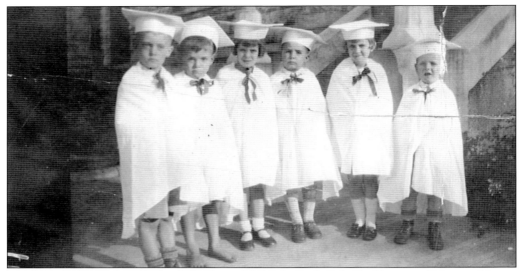

May Stewart Cole, Jennie Fowler Cole, Fannie Hill Cole, Ruth Cole Blackburn, and Minerva Hunter Cole were all founding members of Central Baptist Church's Sarah Hall Missionary Society. In the early days, the ladies assisted poor children in the community by giving them Sunday clothes so that they could attend church. Pictured are children at Central Baptist Church. Minerva Cole Woodroof is photographed fifth from the left. (Courtesy of Minerva Cole Woodroof Winslow.)

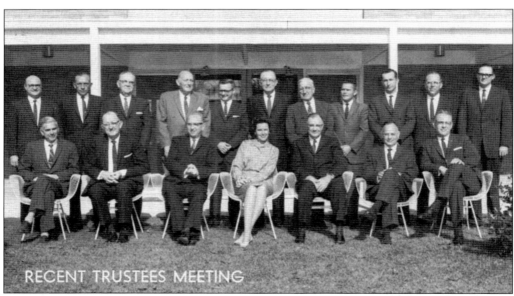

Pictured is the Board of Trustees for the Baptist Village around 1961. Duke Cole Blackburn Sr. stands in the photograph on the second row, second from the left. First opened for residents in 1958, the Baptist Village was a mission of the Georgia Baptist Convention to provide medical services, housing, and ministry to senior adults in Waycross, Georgia. Supporting and being active in the Christian faith has always been at the forefront of the Cole family.

Pictured is Ruth Cole Blackburn in the 1940s. After the death of her husband, Bryan Martin Blackburn, Ruth made a substantial contribution to the Georgia Baptist Children's Home in his memory. Originally located in Hapeville, Georgia, the children's home moved to Palmetto, Georgia, in 1968. The mission of the organization is to care for the "spiritual, physical, and emotional well-being of children, youth, and families."

Photographed is the still-standing original building of Mills Chapel Church at the corner of Murray and Cole Streets in Newnan. As a young girl, Ruth Cole Blackburn, with her aunt May Stewart Cole, taught Sunday school to the children in the mill village surrounding the R.D. Cole Manufacturing Company. This act inspired R.D. Cole Sr. to build and then donate Mills Chapel Church as a mission of Central Baptist Church.

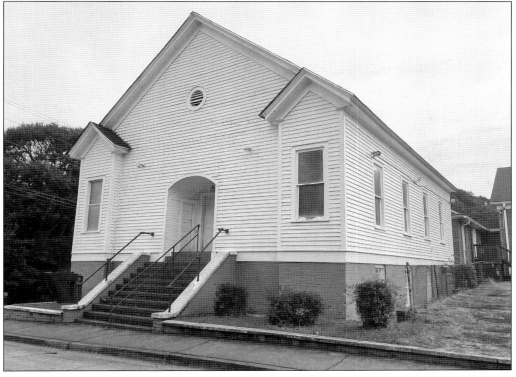

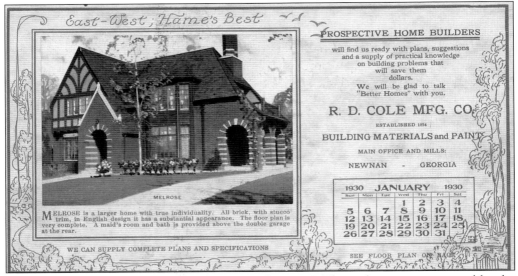

The city of Newnan is nicknamed the "City of Homes." The nickname was inspired by the beautiful antebellum homes that remain in the city's historic area—spared during the Civil War. Many of these homes were constructed by the R.D. Cole Manufacturing Company. The impact of the company was so great that an article in an early-1900s edition of the *Newnan Times and Advertiser* stated: "No home in Coweta County has been untouched by the R.D. Cole Manufacturing Company." This 1930 calendar depicts the Melrose-style model home designed and constructed by the company. (Courtesy of the Newnan-Coweta Historical Society.)

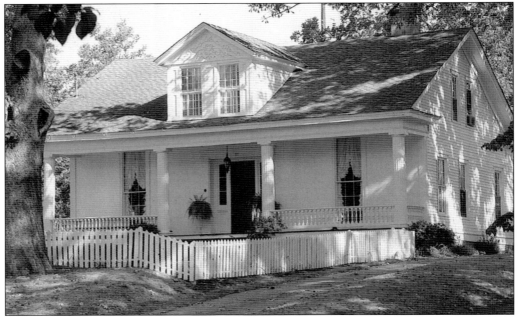

Robert Duke Cole Sr. built the Cole-Roberts home around 1850 in what is now historic downtown Newnan. This home is where Cole lived while running the R.D. Cole Manufacturing Company. The home is an example of the popular story-and-a-half-style homes found throughout Coweta County. (Photograph by Bob Shapiro.)

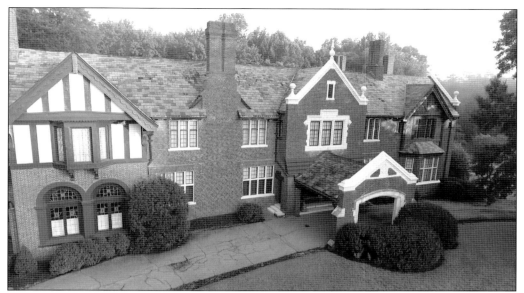

The former Edgar Parrott family home, located on Jackson Street in downtown Newnan, is a 1920s historic English Tudor home designed by Atlanta architect R. Kennon Perry. The R.D. Cole Manufacturing Company contracted the construction of the home and milled the exquisite woodwork, along with the iron and steel products, needed for the build. After the Parrott family, the home has had three other owners, Millard and Catherine Farmer, Joe and Carol Harless, and currently, Anna Conde de Benovic. (Photograph by William Cole Blackburn.)

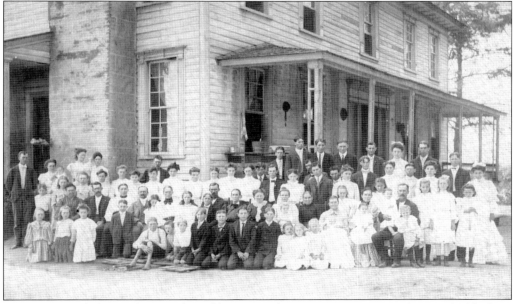

This photograph shows a large triple wedding in northern Coweta County in August 1905 for Lora Hembree and Robert Posey, Mary Odessa Hembree (Lora's sister) and Ezekiel S. Banks, and Lizzie (cousin of Mary and Lora) and Fletcher McGee. Among those pictured here are Hembree, Hines, and Gabel family members. The house in the background is known as the old Arnold home, which may be the first house built by R.D. Cole. (Courtesy of the Newnan-Coweta Historical Society.)

This R.D. Cole Manufacturing Company booklet from 1937 contained selections of small homes available to be contracted and constructed by the company. The R.D. Cole Manufacturing Company advertised that these homes were of moderate costs. The booklet contained several options for families of various sizes, levels, and number of bedrooms and bathrooms. One plan featured inside the booklet was the Sanbury, a two-level home design with two floor plan options. Plan A offered either four or five rooms and one bathroom. Plan B offered six rooms and a bathroom.

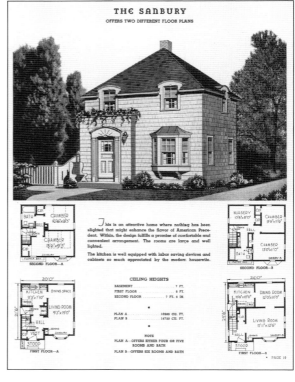

This dollhouse was built by R.D. Cole Manufacturing Company and placed on exhibit for the Coweta Centennial in September 1927. The dollhouse was given to Minerva Cole Woodroof by her father, Edward Guy Cole. The photograph shows the dollhouse after it was moved to Jackson Street on the lot next to the Cole home, seen in the background of the photographs. The room inside the dollhouse had hardwood floors, molding, and baseboards. Working electricity was later added to the dollhouse. The decorative patterns over the front door were made from molds at the R.D. Cole Manufacturing Company. The Chinnedale benches and white picket fence in the yard were also made at the R.D. Cole Manufacturing Company. (Courtesy of Minerva Cole Woodroof Winslow.)

89

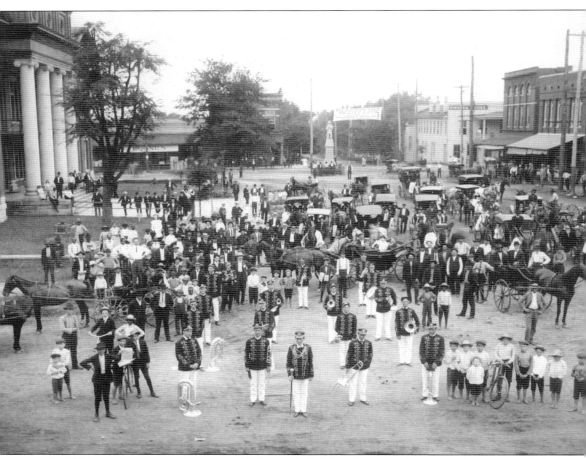

In 1904, county commissioners awarded R.D. Cole Manufacturing Company the winning bid of $56,998 to build a new county courthouse. The first brick for the new building was laid by R.D. Cole Sr. on March 19, 1904. All metal used for the new courthouse was forged at the Cole Shop, and all wood used for construction, including frames, trim, doors, and sash windows, were milled at R.D. Cole Manufacturing Company. The ceremonial cornerstone for the building was laid on June 7, 1904, and a celebration was held in the court square upon completion of the building. This photograph, taken at the celebration, shows a band on the east side of the new courthouse. (Courtesy of the Newnan-Coweta Historical Society.)

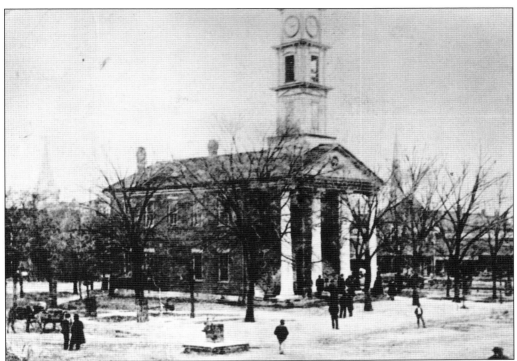

Pictured is the old courthouse, which was demolished in 1904. Some Coweta County citizens opposed the removal of the old courthouse and injunction proceedings threatened to hinder its removal. Due to the controversy, demolition took place at early dawn on a Monday morning on February 22, 1904. Demolition was complete by early March. The old courthouse had previously been used for 76 years. (Courtesy of the Newnan-Coweta Historical Society.)

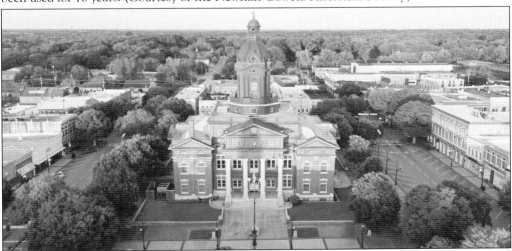

Architect J.W. Golucke of Atlanta drew the beautiful Neoclassical Revival design of the 1904 courthouse. The courthouse features a forged copper sheeting over a timber frame dome. The dome is ornate with clocks on all four sides. The other details of the courthouse include copper cornice pediments and railings along with some stone pediments. The interior consists of marble flooring and intricate woodwork. (Photograph by Will Blackburn.)

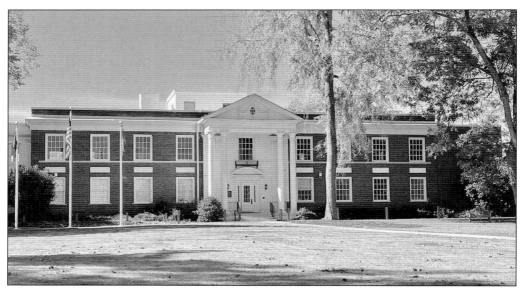

Pictured is the former Newnan Hospital, built in 1925 by R.D. Cole Manufacturing Company. Atlanta architect Kennon Perry designed the building. Bryan Martin Blackburn donated the nondenominational Christian and Jewish chapel used at the building. The chapel featured stained-glass windows and carved wooden pews. The building is now used as the University of West Georgia satellite Newnan campus.

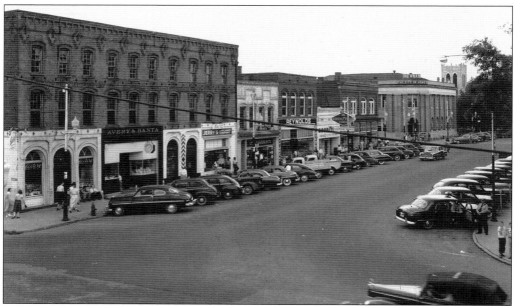

A busy scene is depicted in this c. 1920s–1930s photograph of the historic downtown Newnan square. The light posts were built and installed by the R.D. Cole Manufacturing Company. They were removed from downtown when wiring was placed underground in the 1980s.

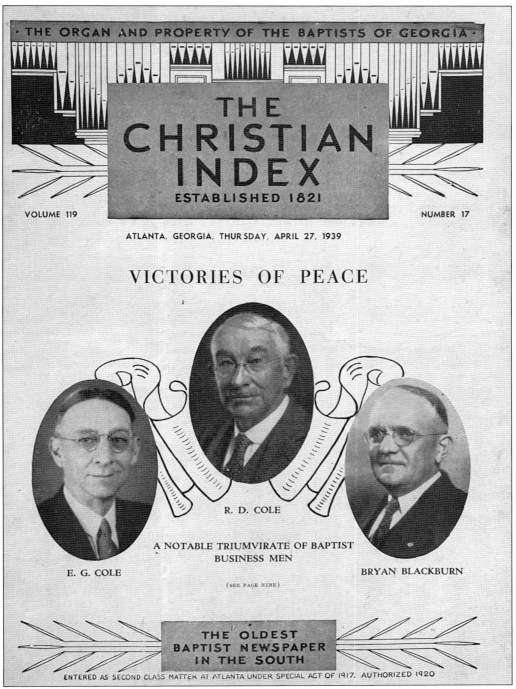

Pictured is a 1939 edition of the magazine the *Christian Index*. Edward Guy Cole, Robert Duke Cole Jr., and Bryan Blackburn are featured on the cover. The men were being congratulated for receiving membership into the national Rice Foundation. The primary objective of the society is to recognize people who have contributed toward development in their community.

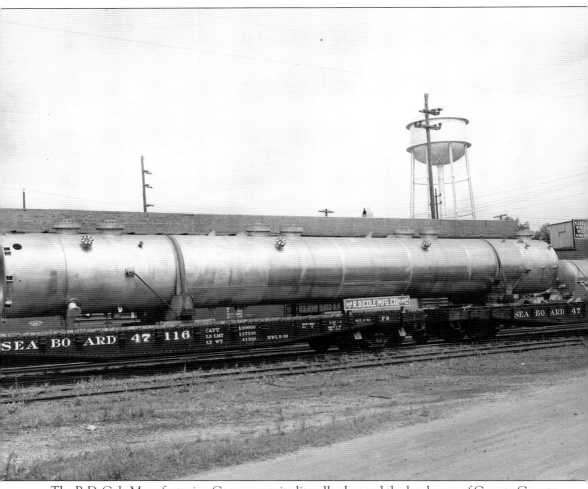

The R.D. Cole Manufacturing Company quite literally changed the landscape of Coweta County, impacting the county on a physical, economic, and social level. Through the construction, manufacturing, and contracting business conducted at R.D. Cole Manufacturing Company, Coweta County saw growth in all sectors. The impact of the Cole family can be seen in politics, schools, religion, business, homes, and many other aspects of Coweta County. This photograph shows the expansive presence of the R.D. Cole Manufacturing Company in Newnan. A creosote pressure vat is loaded onto a flatcar for transport while a water tank built by R.D. Cole Manufacturing can be seen in the background.

Five
WORKING AT R.D. COLE

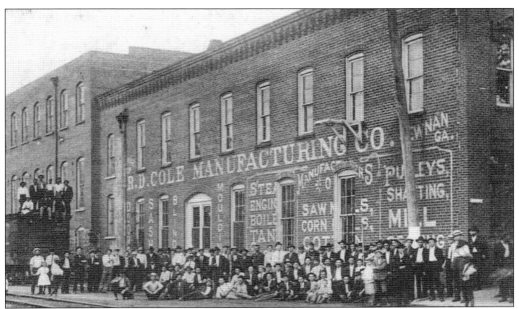

This 1904 photograph features the offices of the workforce of the R.D. Cole Manufacturing Company. The same year, the Honorable Hewlett A. Hall—lawyer, attorney general of Georgia (1910–1911), and family friend of the Cole family—wrote the following about the R.D. Cole Manufacturing Company: "The highest and noblest conception of the use of wealth is found in its investment so as to give employment and aid to mankind."

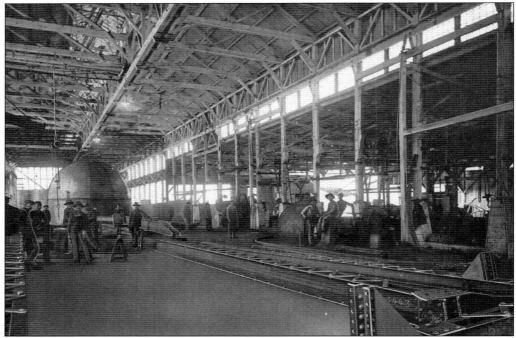

Photographs from the R.D. Cole Manufacturing Company's 1911 tanks and standpipes catalog show the interior of the tank and erecting shop. At the time of the photographs, Frank Bartow Cole was serving as chief executive engineer with A.B. Edge as chief draftsman and Joseph Baughman as engineer. Other office employees at the time were N.B. Hudson (traveling salesman), Willard Newsom (traveling salesman), J.H. Powell (bookkeeper), R.E. Platt (cost bookkeeper), Harry Lundie (shipping clerk), G.R. Spencer (foreman machine shop) and O.L. Ballard (erecting department).

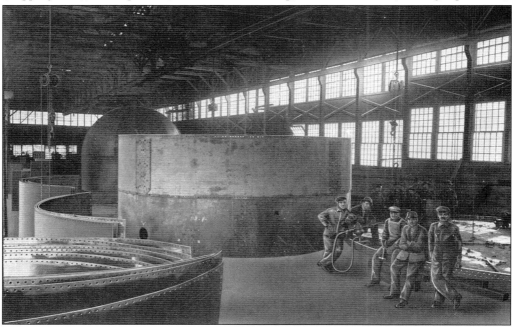

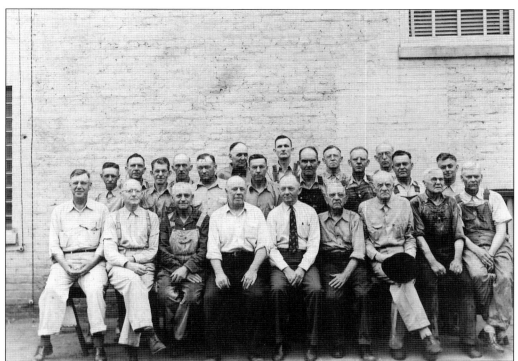

This photograph from 1937 shows R.D. Cole Manufacturing Company foremen who had worked at the company for 25 to 30 years. Pictured here are, from left to right, (first row) Paul Wortham, Harvey Strozier, Will Cagle, John Kersey, John Kite, Walter Mealor Sr., M.E. Spraggin, Arthur Duncan, and Duncan Cook; (second row) Herman Tolbert, E.C. Beers, E.W. "Bill" Brown, Flloyd Hudson, Cliff "Snowball" Ozmore, B.F. Coleman, Albert Mitchell, and Grady "Shorty" Robinson; (third row) Lon Morris, George Beck, Cliff Morgan, Barge Williams, Fred Sisson, and Ned Cavendar. (Courtesy of Katie Barron Brady.)

Pictured is M.E. Spraggin's 1917 R.D. Cole Manufacturing Company time card. Working six days a week, he clocked in by 6:30 a.m. and clocked out around 5:45 p.m. on weekdays and 4:45 p.m. on Saturday with only 30 minutes for lunch. The total time worked indicates a 60-hour workweek with 120 hours worked in two weeks. (Courtesy of Katie Barron Brady.)

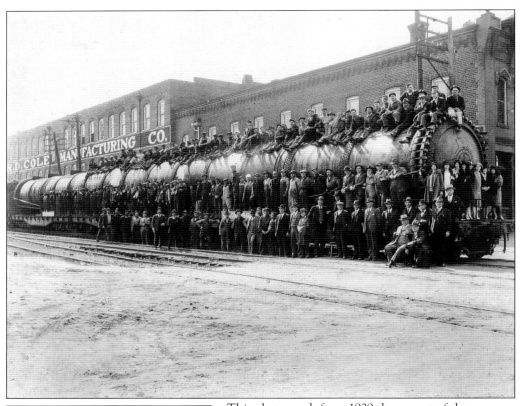

This photograph from 1929 shows part of the R.D. Cole Manufacturing Company workforce celebrating the company's 75th anniversary. The employees are photographed in front of the company offices. Company president R.D. Cole Jr. is sitting in the chair on the far right of the photograph with Bryan Blackburn to his right and Edward Guy Cole Sr. standing behind.

This 1930s photograph shows a riveted cylinder manufactured by the R.D. Cole Manufacturing Company. An unidentified child stands in front of the cylinder.

The R.D. Cole whistle famously blew six times a day at starting time, quitting time, and shift change. The whistle could be heard over five miles away. In 2019, the Newnan-Coweta Historical Society had the whistle restored for display at the Historic Train Depot across the street from the original location of the R.D. Cole Manufacturing Company facility. (Courtesy of the Newnan-Coweta Historical Society.)

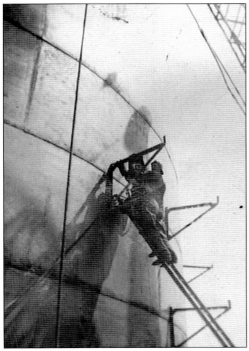

An unidentified employee is shown working on an R.D. Cole Manufacturing Company water tank in this 1940s photograph.

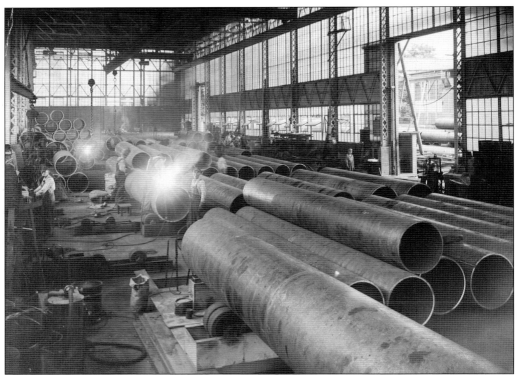

Some R.D. Cole Manufacturing employees are shown working inside the shop in this 1940s photograph. The employees are constructing parts to be used for the manufacturing and erecting of water tanks.

Task field employees in the steel industries are the only ones called "tank builders." Their foreman was referred to as "boss," and the crew included engineers, riveters, welders, and grunts. The grunts climbed up and down the tank all day and got tools. A crew is shown standing in a tank with Frank Owens on the left. Owens was a field foreman for the R.D. Cole Manufacturing Company.

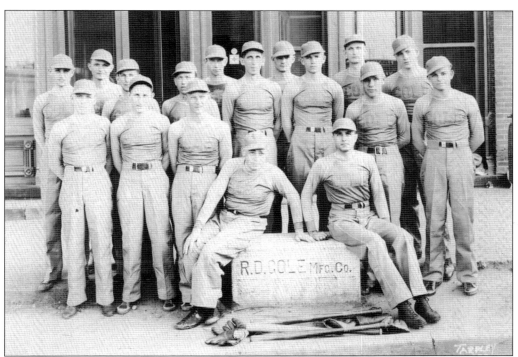

This group of R.D. Cole Manufacturing Company plant workers made up the organization's 1937 softball team. In the photograph are, from left to right, (first row, seated) Charlie Griffith and Fleming Jones; (second row, standing) George Strickland, Sid Boswell, Horace Bowie, Walter Brooks, and Fred Morris; (third row, standing) Harold "Sparky" Keith, Woodrow Miller, Raymond Houston, Robert "Snowball" Ozmore, Charles Johnson, a man thought to be Luther Storey, Wilkes Wilcoxon, Dick Kilgore, Barge Williams, and Bill Doster. (Courtesy of the Newnan-Coweta Historical Society.)

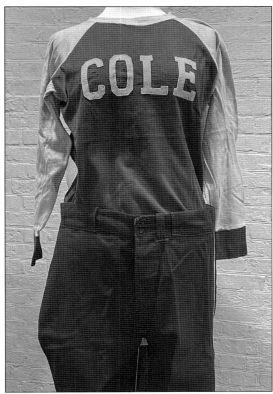

This R.D. Cole Manufacturing Company baseball uniform was donated to the Newnan-Coweta Historical Society in 1986. The inside of the uniform is embroidered with the last name "Barron." The uniform can be seen at the McRitchie-Hollis Museum in Newnan. (Courtesy of the Newnan-Coweta Historical Society.)

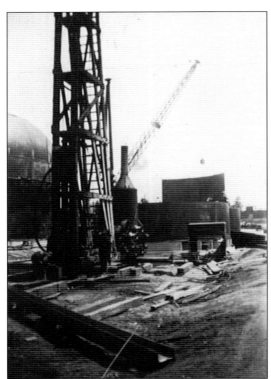

This 1940s photograph shows a field crew of the R.D. Cole Manufacturing Company erecting twin flat-bottom tanks.

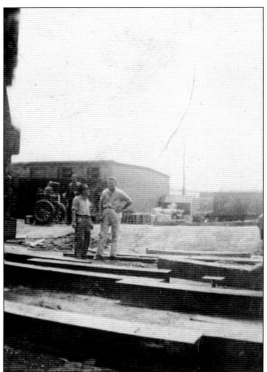

This 1940s photograph shows an employee working on a twin flat bottom tank.

Duke Cole Blackburn Sr. stands on top of an R.D. Cole Manufacturing Company water tank in this 1940s photograph. The other employees photographed are unidentified.

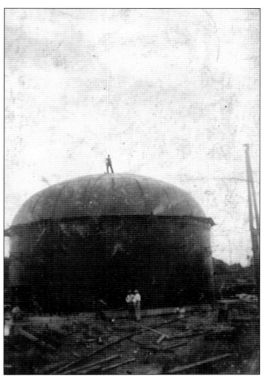

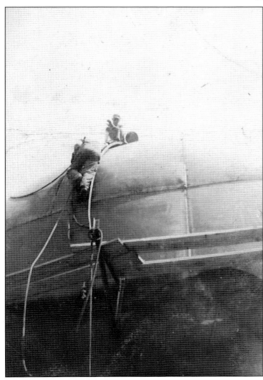

Duke Cole Blackburn Sr. and Clanton "Bull" Reese are shown working on this R.D. Cole Manufacturing Company water tank in the 1940s.

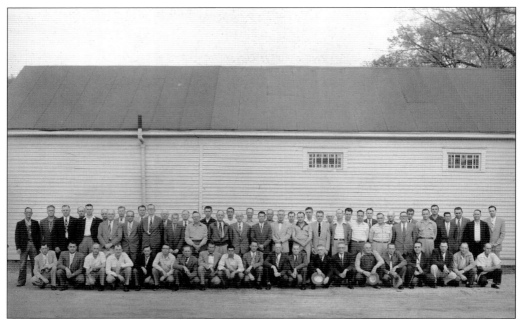

A few R.D. Cole Manufacturing Company employees have been identified in this 1954 photograph. Standing in the second row are, from left to right, Henry Lewis (third), Barge Williams (sixth), E.C. Beers (eighth), T.E. Pope (twelfth), Sid Boswell (thirteenth), Lon Morris (nineteenth), and "Bo" Blair (twentieth).

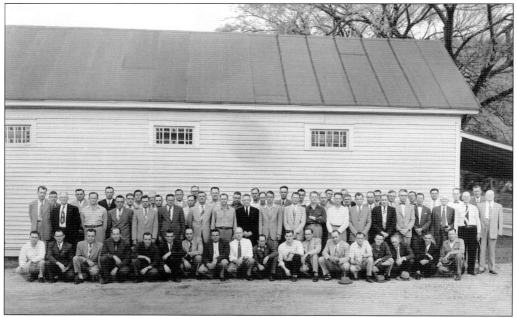

More employees of the R.D. Cole Manufacturing Company are pictured in this 1954 image. Identified are, from left to right, (first row) Fred Morris (eighth) and Grady Wheeler (twelfth); (second row) Duncan Cook (first), Arthur Duncan (second), and M.E. Spraggins (third); (third row) Paul Wortham (fifth), A.S. Kemp (seventeenth), and Hugh McCarley (last).

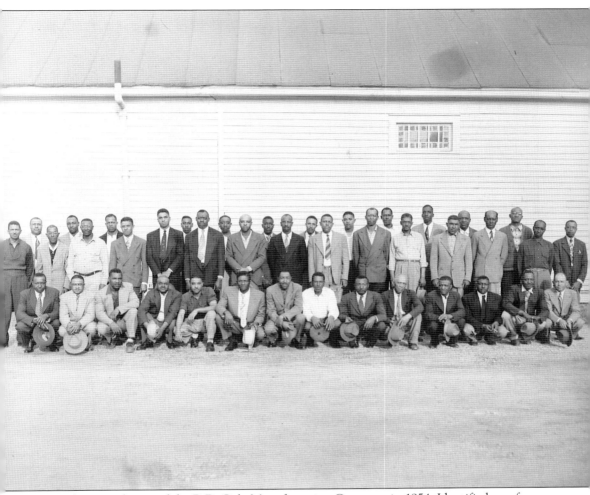

Pictured are employees of the R.D. Cole Manufacturing Company in 1954. Identified are, from left to right, (first row) Major McCrary (third), Jimmy Hendrix (sixth), John Allen Nelson (ninth), Artemus McCrary (thirteenth), and Marion Tompkins (last); (second row) Lawrence Carter (first), Jack Arnold (fifth), Henry Moss (sixth), and Frisk Bohannon (eleventh). (third row) Alfred Ragland (third), J.R. Hall (fifth), James Gay (seventh), and William Smith (eighth). At the time of this photograph, which was taken before the Civil Rights Movement, black employees were photographed separately from white employees.

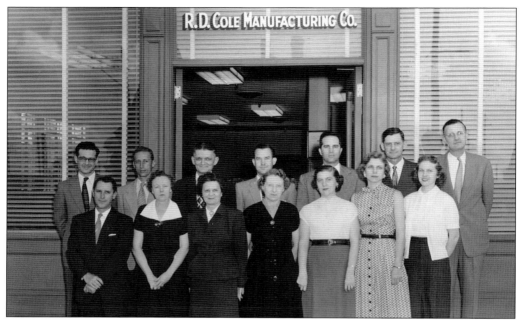

Pictured are R.D. Cole Manufacturing Company clerical, engineering, and office staff from 1954. Pictured are, from left to right, (first row) Fred Joubert, Eloise Johnson, Mrs. Nug Eugene, Joan Spradlin, unidentified, Billie Zane Wilson, and unidentified; (second row) Gilbert Taylor, Jimmy Williams, H. McKoy, Lamar Wood, Andy Muzio, Frank Graham, and J. Harvey Rooks.

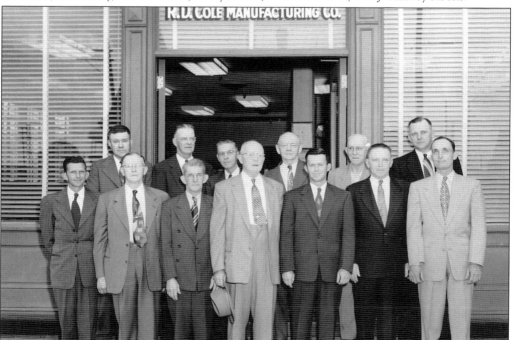

Photographed in 1954 are key office staff with office manager A.B. Fuller. A.B. Fuller is pictured in the exact center of the first row (fourth from the left).

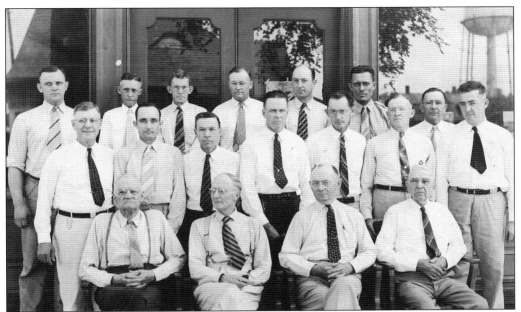

Pictured are R.D. Cole Manufacturing Company planing mill employees from the early 1940s. Shown in the photograph are, from left to right, (first row) M.E. Spraggins, Harey Strozier, John Kite, and Walter Mealor; (second row) Paul Wortham, Grady Wheeler, Floyd Hudson, Henry Hutchens, Emmett Estep, and Fred Scisson Clanton "Bull" Reese; (third row) Henry Lewis, Herman Tolbert, E.C. Beers, E.W. Brown, A.S. Kemp, Hugh McCarley, and L.E. Morris. (Courtesy of Katie Barron Brady.)

John and Ida Kite are pictured here in 1954. John, a foreman, was a longtime employee of the R.D. Cole Manufacturing Company. He was born in 1880 and began working at the shop as a young man. John helped supervise the construction of Central Baptist Church and was instrumental in overseeing the installation of all the fine work molding. He retired in the 1960s.

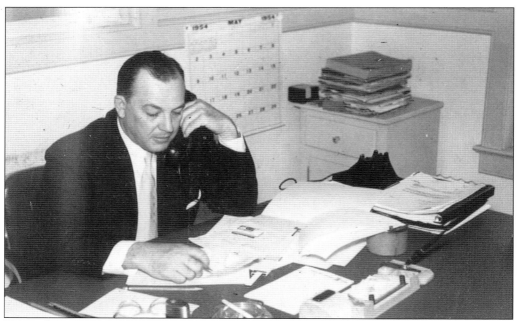

Pictured is John M. Perryman in 1954. He first acted as company sales manager and then vice president of sales. As part of his role, John contracted the sale of the company's water tanks. Working under Perryman as a young man was Hamilton Clay Arnall Jr., R.D. Cole Jr.'s grandson. Hamilton was a graduate of Georgia Tech and served in the Air Force. After R.D. Cole Manufacturing Company sold to Graver Tank and Manufacturing, Arnall became vice president of Graver's Southeast division.

Pictured in 1954 is John Moore Trapnell, chief engineer of R.D. Cole Manufacturing Company and husband of Frances Elizabeth Farmer Trapnell. Both the Trapnell and Farmer families are prominent members of Coweta County.

Shaking hands with Gov. Ellis Arnall is Guy Cole Sr. On August 27, 1943. Governor Arnall and First Lady Mildred Slemons Arnall were in Newnan for the awarding of the coveted Maritime Commission "M" pennant and Victory Fleet Flag to the R.D. Cole Manufacturing Company in recognition of its production of prefabricated ship parts during wartime. Newnan celebrated with a barbecue as it had many times for its hometown governors. Arnall is the grandson to Henry Clay Arnall and cousin to two of the husbands married to Edward Guy Cole's daughters. (Courtesy of the Newnan-Coweta Historical Society.)

Guy Cole Sr. is pictured here with his wife, Minerva Hunter Cole (standing next to him), and his daughter Minerva C. Woodroof (seated at the table). Mr. Guy, as he was called, was considered by employees to be fair and just. The family is enjoying a picnic at their home on Jackson Street in Newnan. (Courtesy of Minerva Cole Woodroof Winslow.)

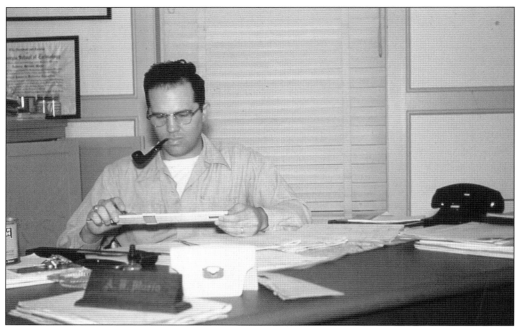

Pictured is R.D. Cole Manufacturing Company employee Andrew "Andy" Muzio in 1954. Andy worked as an engineer for the company. He is a graduate of Georgia Tech and was a US Naval officer serving in both World War II and the Korean War. At the time of his employment, Bryan Blackburn was the executive engineer, and J.M. Trapnell was chief engineer.

Pictured at the reins is Duke Cole Blackburn Jr. with Susan Muzio, Robbie Muzio, and Bryan Martin Blackburn II to his left. Duke and Bryan are the great-grandsons of R.D. Cole Jr. Susan and Robbie are the children of Andy Muzio.

Photographed are, from left to right, Robert Mathew Blackburn, Julia Attaway Blackburn, Duke Cole Blackburn Sr., and Duke Cole Blackburn Jr. Standing in the front is Duke Cole Blackburn III. At a very young age, Duke Cole Blackburn Jr. worked on Saturdays at the R.D. Cole Manufacturing Company weighing nails.

Photographed in 1955 are, from left to right, Edward Guy Cole III, Julie Cole, and Edward Guy Cole Jr. Like his father and several other family members, Edward Guy Cole III also worked at the R.D. Cole Manufacturing Company at a very young age.

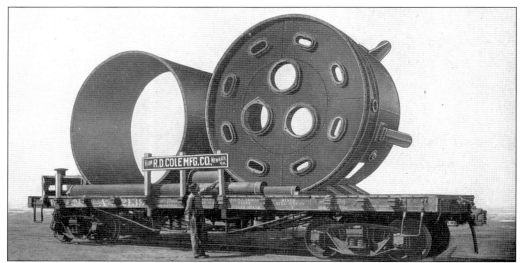

An employee stands in front of an Akerlund Type Gas Producer, manufactured by the R.D. Cole Manufacturing Company. The photograph was featured in one of the company's elevated tanks and standpipe brochures.

This is the interior reception area of R.D. Cole Manufacturing Company. Originally constructed in 1890, the interior was renovated using wood and stainless-steel plates to create the reception counter. In the center background is the company vault with an ornate wooden door frame. Bryan Blackburn and Duke Cole Blackburn Jr.'s office was to the left, and Guy Cole and Edward Guy Cole's office (not pictured) was to the right.

Six
The End of an Era

In 1954, the R.D. Cole Manufacturing Company celebrated its 100th anniversary. Pictured is the uncovering of a bronze plaque commemorating the milestone presented by the employees. Pictured are, from left to right, Edward Guy Cole Jr., Duke Cole Blackburn Sr., Bryan Martin Blackburn, and Edward Guy Cole Sr. Gathered to the right are employees of the company.

For the 100th anniversary celebration, the company had a barbecue honoring the employees, opened the workplace for the community to tour, and served free Coca-Cola drinks to everyone. Photographed are visitors at the R.D. Cole Manufacturing Company facility standing in line to receive their drinks.

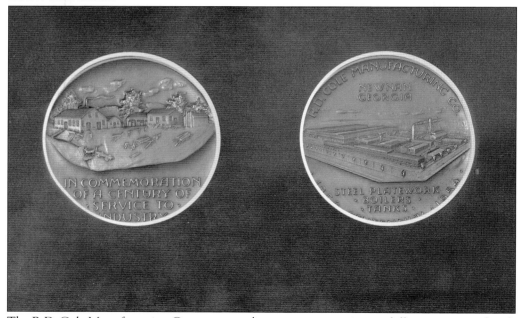

The R.D. Cole Manufacturing Company sent brass commemorative medallions, imprinted with a picture of the company, to associate businesses throughout the United States. Photographed is one of the brass medallions sent to employees and affiliates.

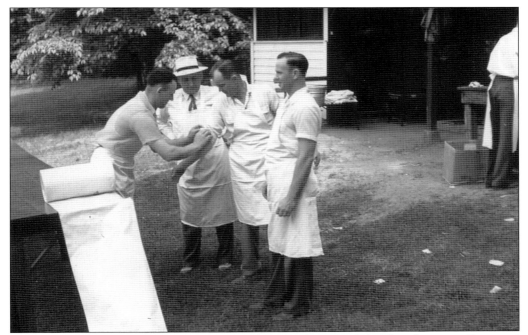

Pictured in 1954 is Wilkes Wilcoxon, an employee at the R.D. Cole Manufacturing Company, rolling up his sleeves to help serve barbecue at the celebratory event. About 800 people attended the 100th anniversary celebration.

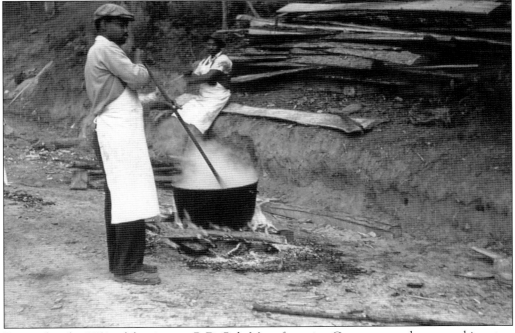

Pictured at the 1954 celebration are R.D. Cole Manufacturing Company employees cooking stew in an iron pot over open fire and meat in a charcoal pit. Stew, barbecue, potato chips, and an assortment of pickles were served for the 100th anniversary celebration.

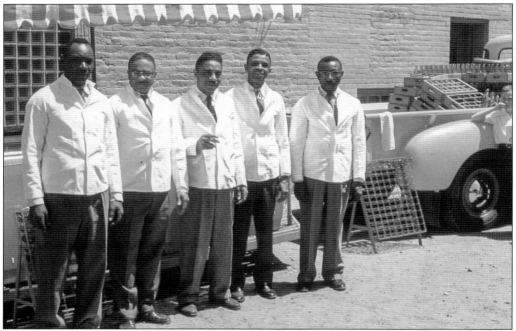
Employees in their white coats served Coca-Cola drinks to visitors touring the R.D. Cole Manufacturing facility during the day and employees attending the evening barbecue at the 100th anniversary celebration.

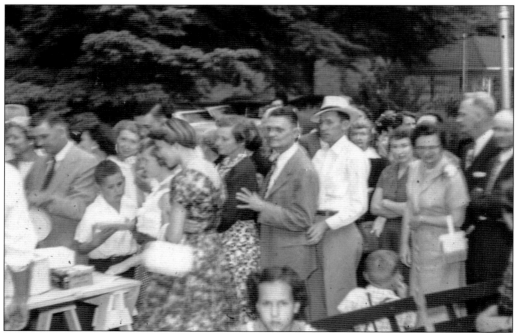
Pictured in 1954 are employees in line for barbecue. In the middle of the photograph, Herbert McKoy is shown with his hand on the arm of his wife, Rosalyn Askew McKoy. Herbert McKoy was a foreman employee at the R.D. Cole Manufacturing.

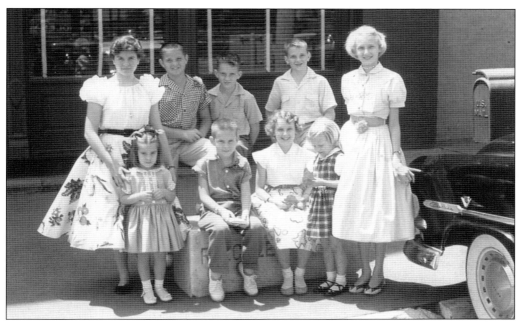

Pictured are children of the Cole family in 1954 at the R.D. Cole Manufacturing Company's 100th anniversary celebration. From left to right are (first row) Julie Cole, Edward Guy Cole III, Bee Hammett, and Catherine Hammett; (second row) Susanne Jones, Otis Fleming Jones Jr., George B. Sargent, Bryan B. Sargent, and Ruth Hammett.

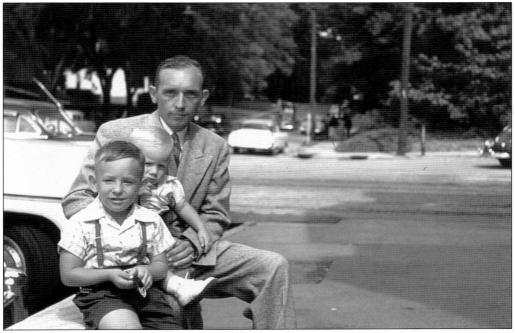

Pictured is Duke Cole Blackburn Sr. at the R.D. Cole Manufacturing Company's 100th anniversary celebration in 1954 with his sons Duke Cole Blackburn Jr. sitting in front and Bryan Martin Blackburn II on his lap.

117

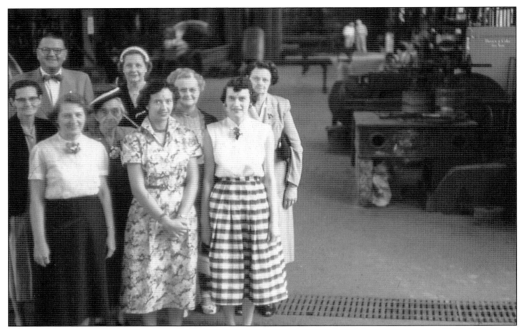

These visitors were photographed while taking a tour of the inside of the company in 1954. Elizabeth Beers (in the floral dress) was a local historian who lived in "Cole Town," one of the six historic districts in Newnan. The name was given to the area around what is now East Broad in tribute to the founders of R.D. Cole Manufacturing Company and their many employees. Elizabeth once commented, "One of the reasons the employees and owners of the R.D. Cole Company had such a good relationship was due to living in the same neighborhood."

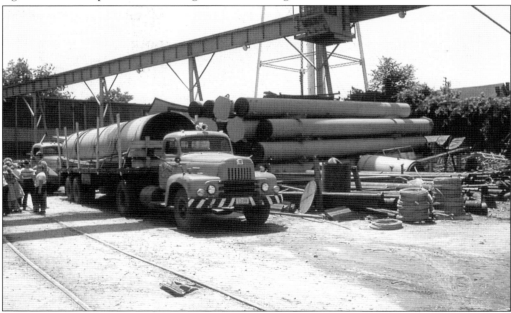

As part of the 1954 100th anniversary celebration, visitors took a tour of R.D. Cole Manufacturing Company. Pictured is the loading yard with an overhead bridge crane known as a gantry crane.

Bryan Martin Blackburn died on December 17, 1955, with Edward Guy Cole Sr. following in death on March 11, 1958. Here, they are pictured with grandchildren in 1954 at the 100-year celebration of the R.D. Cole Manufacturing Company. Blackburn is pictured above, and Cole is shown below. The deaths of these men, along with R.D. Cole Jr., ushered in a new era at the R.D. Cole Manufacturing Company with new management who ultimately made the decision to sell the company. Bryan Blackburn is pictured with Bryan Blackburn II next to him and his daughter-in-law Julia to the right. Edward Guy Cole is pictured with Emory Holland.

119

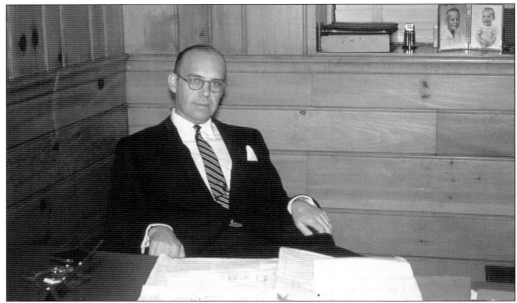

In 1957, the R.D. Cole Manufacturing Company once again changed ownership but still remained in the Cole family. While ownership was previously equally held between two sides of the family, the Edward Guy Cole side of the family bought the stock held by Bryan Martin Blackburn's heirs. With the sale of the company, Edward Guy Cole Jr. became president and treasurer, photographed here in 1954.

In 1957, Hamilton C. Arnall became vice president of the company with T.K. Barron as secretary, J.M. Trapnell as vice president of engineering, W.E. Shefelton as vice president of production, and J.B. Fuller as office manager. Pictured are Hamilton C. Arnall and his wife, Frances Cole Arnall. Hamilton C. Arnall also owned a successful insurance company and served on the Newnan Cotton Mill board.

Pictured are Henry D. Sargent and his wife, Fannie Cole Blackburn Sargent. Henry received his degree from Georgia Tech in Textile Engineering. He worked as an executive in purchasing for R.D. Cole Manufacturing Company. Henry and Frances had three children, Frances B. Sargent, George B. Sargent, and Bryan B. Sargent. Henry and Fannie were stock owners in the company.

Son of Otis Jones and Ruby Fleming Jones, Otis Fleming Jones received his degree from Georgia Tech in management. At the R.D. Cole Manufacturing Company, he worked as an executive in retail before becoming assistant treasurer in 1957. He is pictured here next to his wife, Annie Cole Jones, at the company's centennial celebration. The couple had two children, Otis Fleming Jones Jr. and Susanne Cole Jones. Fleming and Annie were stock owners in the company.

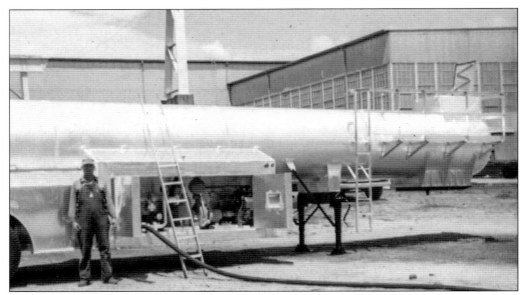

Pictured is R.D. Cole Manufacturing Company employee Sid Boswell standing beside an aluminum chemical storage tank. By the 1960s, the R.D. Cole Manufacturing Company was one of the largest steel industries in the United State and conducted business in several foreign countries. It was winning bids for construction projects against companies such as Pittsburgh-Des Moines Steel Company and Chicago Bridge and Iron and held valuable contracts with companies such as DuPont.

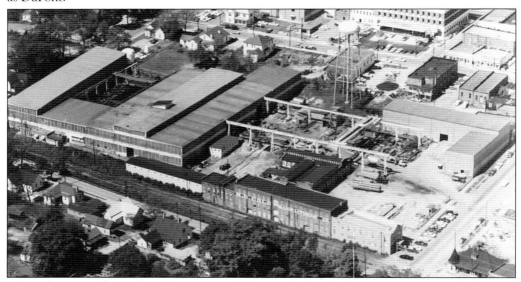

Through wars, industrial revolution, and all the trials that the business encountered, the R.D. Cole Manufacturing Company remained faithful in its religion and honest and fair in business. After 114 years of being a family-owned business, R.D. Cole Manufacturing Company sold to Garver Tank and Manufacturing Company, a subsidiary of the Union Tank Car Company in Chicago, Illinois, in 1968. The company was purchased to produce petroleum and chemical storage tanks and other storage vessels. Photographed is an aerial view of the R.D. Cole Manufacturing Company in the 1960s.

In 1971, the R.D. Cole Manufacturing Company site was resold to Brown Steel Contractors and used to build water tanks on site. Brown Steel Contractors was already a leading business in Coweta County since 1945, operating at another location. Brown Steel Contractors was one of the largest tank builders in the United States. Photographed is the R.D. Cole Manufacturing Company office renovated as the Brown Steel Contractors office building. (Courtesy of the Newnan-Coweta Historical Society.)

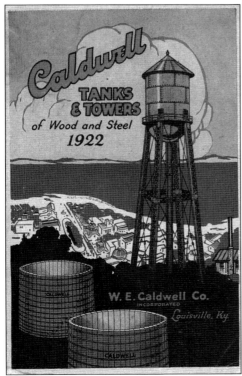

In 1994, Caldwell Tanks of Louisville, Kentucky, purchased the facility. Caldwell Tanks was established in 1887 and incorporated in 1892. The company focused its manufacturing efforts on the construction of water tanks, both made of wood and steel. Caldwell tanks stayed at the Newnan site until 2013. At that time, the Broad Street site was vacated and has since sat empty. Pictured is a 1922 Caldwell tank brochure cover. (Courtesy of the Newnan-Coweta Historical Society.)

On March 12, 2021, the City of Newnan purchased the Caldwell Tanks property from Broad Street Forum, Inc. The 6.68-acre property that once housed the R.D. Cole Manufacturing Company is currently in the development phase. The plan is for the site to become multipurpose with retail space, office space, greenspace/plaza space, and residential space. Unfortunately, the property has fallen into such disrepair that the buildings cannot be saved for restoration when the property is redeveloped due to cost. Pictured above is the outside of the Caldwell Tank/R.D. Cole Manufacturing Company property in 2021. Pictured below in 2021 is the inside of one of the shops prior to demolition. (Both, courtesy of the Newnan-Coweta Historical Society.)

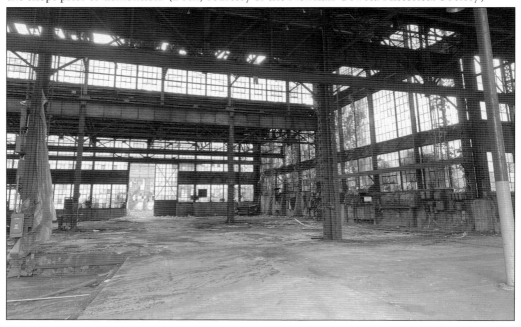

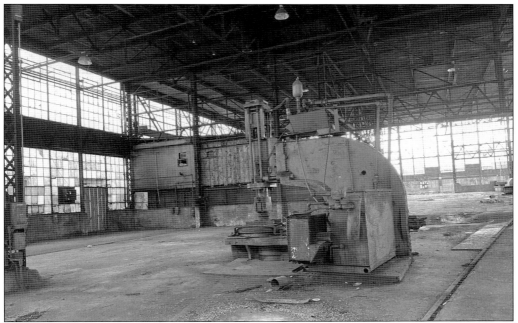

According to Newnan City manager Cleatus Phillips, facets of the R.D. Cole Manufacturing Company facility will be saved and repurposed in the redevelopment project. City crews have already removed several pieces of equipment to be preserved and displayed as historic artifacts and art pieces. The city also plans on saving some of the building's bricks, flooring, and wood framing to be used in the redevelopment and asking the redeveloper to integrate design elements that were present at the manufacturing site. Pictured above is a piece of equipment from Caldwell Tanks left inside the shop. Pictured below is the inside of one of the older buildings on the site in 2021. (Both, courtesy of the Newnan-Coweta Historical Society.)

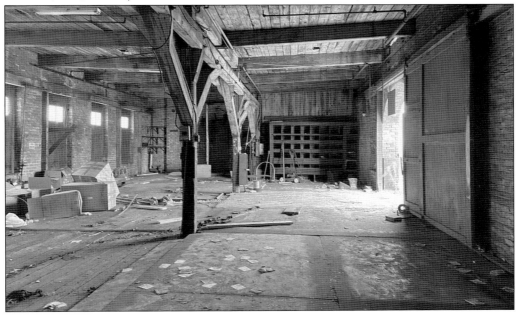

The history of the R.D. Cole Manufacturing Company remains a source of pride for the family. Several still live in Coweta County and are prominent members of the community. Pictured after the Newnan Courthouse centennial celebration at the home of Lynn and Duke Blackburn in 2004 are Cole descendants. Pictured are, from left to right, (first row) William Cole Woodroof, Minerva Woodroof Winslow, Mary Page Sargent, Benjamin Cole Blackburn, Lynn Hurley Blackburn, and Mathew Avary Pinson; (second row) Otis Fleming Jones III, Edward Guy Cole III, Duke Cole Blackburn Jr., and Mary Frances Pinson; (third row) Otis Fleming Jones Jr., Mary Margaret Woodroof, Minerva Cole Woodroof, Ellen Pettie Sargent, Christopher Henry Sargent, George Blackburn Sargent, Bryan Blackburn Sargent, Diane Browder Sargent, and Ann Welch Jones.

About the Newnan-Coweta Historical Society

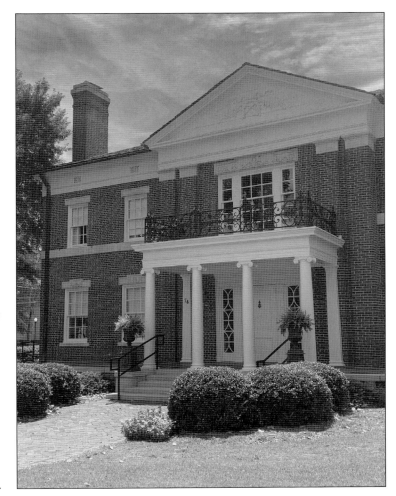

The Newnan-Coweta Historical Society (NCHS) is a nonprofit dedicated to the interpretation and preservation of the historical, cultural, and architectural heritage of Coweta County, Georgia. NCHS operates the McRitchie-Hollis Museum at 74 Jackson Street and the Historic Train Depot at 60 East Broad Street in Newnan. Through programs, exhibits, and collections that promote local history, NCHS seeks to serve, engage, and educate the diverse communities of Coweta County and the surrounding region.

DISCOVER THOUSANDS OF LOCAL HISTORY BOOKS FEATURING MILLIONS OF VINTAGE IMAGES

Arcadia Publishing, the leading local history publisher in the United States, is committed to making history accessible and meaningful through publishing books that celebrate and preserve the heritage of America's people and places.

Find more books like this at
www.arcadiapublishing.com

Search for your hometown history, your old stomping grounds, and even your favorite sports team.

Consistent with our mission to preserve history on a local level, this book was printed in South Carolina on American-made paper and manufactured entirely in the United States. Products carrying the accredited Forest Stewardship Council (FSC) label are printed on 100 percent FSC-certified paper.